DATE DUE

DEMCO 38-296

CONTESTING THE SUPER BOWL

CONTESTING THE SUPER BOWL

Dona Schwartz

WITH PHOTOGRAPHS BY

David Rae Morris · Randall Johnson ·

Steve Schneider · Diane Bush · Donna Kelly ·

John Haselmann · Michael Branscom ·

Amitava Kumar

ROUTLEDGE LONDON NEW YORK

Published in 1998 by

Routledge
29 West 35th Street
New York, NY 10001

Published in Great Britain by

Routledge
11 New Fetter Lane
London EC4P 4EE

Copyright © 1998 by Routledge, Inc.

Printed in the United States of America on acid free paper

Library of Congress Cataloging-in-Publication Data

Schwartz, Dona.
 Contesting the Super Bowl/Dona Schwartz.
 p. cm.
 Includes bibliographical references and index.
 ISBN 0-415-91952-5 (cloth). — ISBN 0-415-91953-3 (paper)
 1.Super Bowl (Football game) — Social aspects. 2. Super Bowl (Football game) —Pictorial
works. 3. Minneapolis Metropolitan Area (Minn.) 4. Buffalo Bills (Football team) %. Washington
Redskins (Football team) I. Title.
GV956.2.S8S38 1998
796.332'648--dc21
 97-214
 CIP

Contents

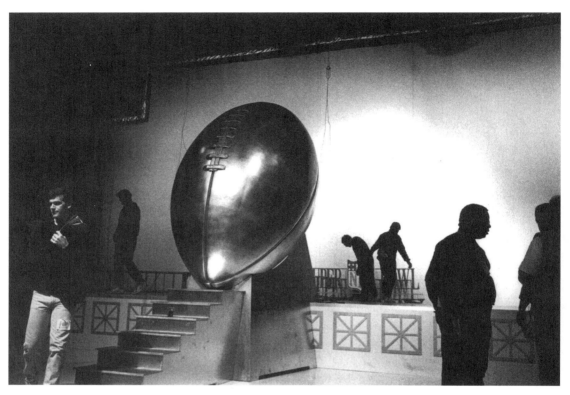

The Radio City Productions crew dresses the stage for "Super Bowl Saturday Night," emceed by Burt Reynolds.

FOR DANIEL, ERIC, AND LARA

Camera Ready

In January 1992 an American cultural spectacle took place in my hometown—the Super Bowl. I had nearly succeeded in ignoring the whirlwind upending Minneapolis-St. Paul. Then a moment of revelation convinced me that I was about to let an extraordinary opportunity slip by. Reconsidered from the vantage point of my interest in media studies, I could see that I had been presented with a chance to study the phenomenon behind the media event—the real Super Bowl, live and offscreen. Like many Americans, I had swallowed my dose of Super Bowl telecasts and I felt I had developed at least a rudimentary understanding of the image constructed in the course of the annual media fest. I assumed the media and the National Football League intended otherwise, but nevertheless, I read the Super Bowl as a celebratory junction of corporate capitalism, masculinity, and power that hegemonically affirms and perpetuates inequality. Certainly my outsider perspective was enhanced by my gender; I could find no compelling heroines among the token female sportscasters, the cheerleaders, or the members of the Swedish Bikini Team.

My goal emerged in the midst of the media hype that escalated as the Super Bowl approached. A relentless stream of promotional reporting emanated from the local press and assertions regarding the benefits the Super Bowl would deliver abounded. A few maverick reporters challenged the prevailing sentiment, giving voice to doubts shared by many local residents. Which was the more accurate claim? Would the Super Bowl be a boon or a debacle? How would the benefits and the costs be distributed? As I began taking stock of the frenetic activity transforming my familiar environment I was convinced that I should seize the opportunity before me. As an ethnographer and a documentary photographer I intended to construct a representation of the Super Bowl

different from the image that would play in the commercial media, a portrayal that could serve a different didactic purpose. In short, I wanted first to discover and then to show, from a social scientist's perspective, what happens when a Super Bowl comes to town. I should make it clear that I did not enter the field a *tabula rasa*. I was armed with a theory about the role of the Super Bowl in American cultural life, and I was committed to putting my theory to the test as the fieldwork proceeded. The mainstream media defined the impending contest as a championship football game, while the engagement I envisioned was a contest for meaning.

Because I had primarily witnessed the Super Bowl as a televised media event—a football game—I had not fully appreciated the kind of activity it generates. The Super Bowl is the season's culmination, celebrating revenues accumulated by the NFL, team owners, advertisers, the media, and the many satellite industries that share profits generated by professional football. Perpetuating the commerce it venerates, CEOs use the Super Bowl as a vehicle to cement deals, entertain clients, reward productive employees with a free excursion, and simultaneously create tax deductions. The media take advantage of the event they helped craft, and the Super Bowl is placed among items at the top of the week's news agenda. Sportswriters, newscasters, talk show hosts, protesters, and celebrities of every ilk converge on the host city to produce and exploit the media spectacle that unfolds. On the local front, Minnesota's corporate elite joined forces to maximize the opportunity availed them by the Super Bowl. The Minnesota Super Bowl XXVI Task Force prepared ten days of festive events intended to draw in visitors and induce them to spend as much money as possible. While cheerfully tallying cash register receipts, the task force hoped to showcase Minneapolis-St. Paul as a favorable site for business travel, year-round. Local leaders eagerly anticipated a future of Super Bowl-induced economic growth.

As the enormity of my endeavor became apparent I invited several local photographers to join the effort: David Rae Morris, Randall Johnson, Diane Bush, Donna Kelly, John Haselmann, Michael Branscom, Amitava Kumar, and Steve Schneider. We affirmed our goals, divided the territory, and as the days passed we repeatedly rendezvoused to share information, ideas, and inferences. We told stories about our experiences and wrote them down in journals. As we became immersed in our task I found myself and others around me being swept up in the momentum of the events we came to observe. I confess that I began to enjoy playing the role of a media maker, with all its attendant perks—the abundant food and drink, the parties, the authority that comes with privilege. Acknowledging this seduction, we conscientiously worked to avoid reproducing the ideas, the attitudes, and the depictions made by our commercial counterparts, our version of "going native."

Ten days of fieldwork and photography revealed a dense thicket of interests and influences that resisted being easily untangled. There could be no simple, straightforward response crafted from this encounter with the Super Bowl. And I discovered another problem, even thornier than the daunting complexity of the social dynamics I had set out to understand. It had been my intention to fix attention on the events unfolding in front of our cameras, but the process of preparing for and shooting the Super Bowl ultimately forced an unanticipated confrontation with the goals I had laid out at the start. It became increasingly clear that my fact-finding mission was compromised by our own

communicative apparatus. I knew I would be unable to profess that we had uncovered the real Super Bowl. What we did discover, however, may have broader implications for our understanding of mass communication processes, and especially the social construction of meaning through the vehicle of photography.

BEARING WITNESS Despite the established tradition of photographers "bearing witness," the documentary process has been relentlessly buffeted by challenges that erode its privileged status.[1] The simple notion that photographs offer a mirror of reality has been shelved by most scholars and replaced by a more complex view of photographic communication. Rather than residing in the image, photographic meaning emerges in the course of social interaction.[2] Photographs result from the social interaction between photographers and their subjects; each contributes to the image, and the circumstances surrounding the creation of the photograph help to shape the outcome. Once the photograph has been created viewers engage in the activity of interpretation; the text offers a finite range of available meanings to which the spectator responds, negotiating an interpretation through the filter of his or her experience.

Other factors play a significant role in shaping photographic meaning. The institutional setting in which photographic activity occurs triggers a system of codes and conventions and a set of expectations to which both photographers and viewers respond.[3] Arenas of photographic production, either occupational or avocational, offer measures of success and failure internalized by photographers and viewers. Photojournalism, fine arts photography, and snapshot photography, for example, have all generated a distinctive set of practices and expectations governing the social production of meaning. We have come to expect certain kinds of images to emerge from specific institutional domains. Editors, curators, and family members may serve as the gatekeepers who inculcate photographic norms appropriate to the settings in which they act. In addition to these contextual influences, the photographic industry plays an important role in delimiting the range of possible photographic outcomes. Because the industry chooses to manufacture those products with the most potential profitability, mass market imperatives determine the kinds of equipment and materials most readily available to picture makers.[4]

Another dynamic became especially salient in the course of our fieldwork, a less scrutinized mechanism for the construction of photographic meaning. Politicians and publicists both have become increasingly aware of the currency of appearances, and the potential benefits of managing the look of reality through the manipulation of the photographic image. The term "photo opportunity" has entered popular discourse, as events and pseudo-events are increasingly staged for consumption by the mass media, feeding its voracious appetite for sound and image bites.[5] Recently, a new trend in image management has emerged—the "video news release"—a visual press release issued in a form that broadcasters can easily edit into news programs, saving the time and effort of shrinking news staffs. The demand for image management has led to the emergence of a cadre of professional consultants and entrepreneurs who advise clients on strategies to produce desirable appearances and who make visual packages to sell to the media. The ability to control the appearance of reality is an additional resource distinguishing the power elite in the late twentieth century. Many frustrated photojournalists have begun to see themselves as submissive lapdogs, unable to live up to the obligations assumed by feistier watchdogs, because they are prevented from seeing anything that has not been

staged and sanctioned appropriate for photographic consumption and mass distribution.

The photojournalist plays a pivotal role in this process, providing images to be published under the mantle of neutrality in the press, their messages reified as truth. When photojournalists portray people who harness neither the knowledge nor the resources necessary to govern access and appearance, they and their editors control the process of representation, and another collective version of "the truth" results. All photographers concerned with the factual integrity of their work must necessarily confront these questions: Can we portray events unencumbered by the appearances fashioned by powerful interest groups? If so, what kind of alternative imagery can we offer? Will our good intentions yield images that more accurately represent the complexity of events? Can we find mechanisms and practices that allow us to address the power imbalance among subjects when we craft representations of the social world?

These issues moved from the theoretical to the concrete as we attempted to photograph the Super Bowl. We encountered and attempted to thwart mechanisms by which imagery is manipulated by those who set the stage. Not only do the efforts of event planners affect what appears in the viewfinder—we also witnessed the impact of these constructions on the behavior of event participants. The image of the Super Bowl created and promoted by power elites permeated every facet of the activity around us. Even protest was framed within the hegemony of the crafted appearances.[6] As our work proceeded we discovered several image-management strategies designed to yield a positive representation of events, participants, and locales.

ACCESS Our attempt at producing an alternative portrayal of the Super Bowl required us to represent events open to the public, events restricted to and staged for the media, and private activities not intended for public scrutiny. Private parties or receptions might be photographed, but only for the use of the sponsoring agency or individuals involved. Given the array of activities and events, the most obvious control mechanism is selective access. Anyone can photograph an event open to the public, although the movements of a non credentialed photographer may be restricted. Media credentials are required to join the ranks of professional photographers, and using my position as a member of the faculty at the University of Minnesota Journalism School, I was able to get NFL press pins for five photographers, in addition to two press passes to the Super Bowl game itself. Members of our photographic team without press pins could not enter the press lounge, nor attend press openings and parties. A dangling press pass and an attitude of entitlement opened many doors closed to unaffiliated shooters.

With the legitimized status of professional photographer comes a set of expectations with regard to photographic practice. Admission to the ranks offers the comfort of group membership, which often inculcates a herd mentality. Press photographers have internalized the expectations of their editors and they often share a conception of what should be photographed, from what angle, with what lens, and from what point of view.[7] Diverging from the consensual wisdom of the pack earns the errant photographer the suspicion of colleagues and security guards. The constraining influence of conformity should not be underestimated; the response to a photographer who doesn't behave in a recognizably professional manner is more difficult to endure than the fellowship of congruity. Well fed and entertained, press photographers are offered a variety of photo

opportunities, making reportage a matter of point-and-shoot. Few photographers sent to cover the Super Bowl would be likely to venture behind the scenes to see who is working in the kitchen or living in the alley behind the hotel.

While official credentials facilitated access to many events and activities, no credentials other than membership in the participating group would get a photographer into most private functions. Restricting access grants participants in some events a level of privacy others cannot expect. When seeking permission to attend and photograph several corporate-sponsored parties, I was flatly refused by company public relations officials, who confided that someone might be misbehaving or cavorting with "the wrong partner." In fact, many companies made it a policy to prohibit photographers at parties. While some companies and groups denied me permission to photograph, others granted my request, and I encountered varying degrees of decorum, silliness, and drink-induced boorishness. At one party I was initially mistaken for the photographer hired by the group, and I was given instructions by the group's tour guide. "Don't photograph people eating," she complained. "Show the revelry! The revelry!"

Activities planned by individuals such as business meetings, dinners, or sightseeing are more inaccessible than organized events, and our representation cannot account for this arena of Super Bowl activity. By omission, our portrayal perpetuates the privilege of privacy. Regardless of the access granted, it is generally understood that a photographer will accomplish the task at hand and then leave. Photographers record events, popular wisdom teaches, and one picture is as good as another so long as the deed is done. Permission to shoot may be granted with the understanding that a few shots will be all that is needed; photographers who stay longer are greeted with scant patience, while an extended presence earns hostility. Controlling who shoots and what can be accessed defines the terms of representation and limits the possible range of meanings created.

SETTINGS Anticipation of photography led to the transformation of the appearance of Minneapolis-St. Paul. Because the football stadium is located in Minneapolis, most of the effort was devoted to festooning its downtown with banners sporting local corporate logos. Spotlights shaped like Coca-Cola cans gyrated in parking lots and giant inflatable Budweiser beer cans sprouted strategically from rooftops near the Metrodome, where they were sure to appear in photographs and television cutaways from the broadcast of the football game. Signs of the Super Bowl appeared throughout the city, and the official NFL Super Bowl logo adhered to storefronts and colorful displays of merchandise. Linking themselves to the Super Bowl, small businesses decorated exteriors and interiors to attract the tourist trade. Churches likewise hung banners welcoming Super Bowl fans. Billboards designed for display during the Super Bowl featured such novelties as bowls of soup with steam issuing forth. In tune with the "Great Minnesota Warm-Up" theme proclaimed on banners hung throughout town, orange and red signs hung throughout the city's skyways, offering directions to tourists.

The Metrodome, nestled amid the Budweiser and Coca-Cola hospitality tents, also received special treatment. Inside, play-off team banners hung alongside the corporate advertisements already in place. In conjunction with the Super Bowl, Sony donated a giant state-of-the-art video screen, the "jumbotron," to residents of Minneapolis-St. Paul.

In the evenings, lasers traced the Super Bowl logo on the outside of the dome, along with drawings of fans quaffing cocktails.

Regardless of where photographers aimed their cameras, the shots they composed inevitably framed corporate logos and Super Bowl decorations, reminders of the sponsors responsible for the good times at hand. Corporations competed for prime space, places where photographers could be expected. The repetitive appearance of corporate logos in press photographs reaffirmed the presence, power, and privilege of corporate America. And inescapably, that presence was made manifest in our images.

EVENTS The Super Bowl XXVI Task Force, in cooperation with the National Football League, scheduled a series of "official" events, published in brochures and distributed to residents and visitors. An aerobic workout featured fitness celebrities and local sports stars; kids attended a football clinic with professional players; football stars signed autographs for their fans; and throughout the skyways of downtown Minneapolis, entertainers performed for the Party Under Glass. The NFL hosted its own events, among them an awards dinner, and a celebrity variety show broadcast live on television. There were daily press conferences with coaches and key players, and a Media Day at the dome, where all members of the competing football teams were available for interviews and photos.

Corporations announced their own "events." Budweiser hosted the Bud Bowl, Campbell's Soup invited viewers to see the "world's largest bowl of soup," and promoters of the world's largest shopping mall, the Mall of America, bused journalists to the site for a free tour and dinner followed by NHL hockey and dessert at the nearby Met Center. Gala fund-raisers exploited the presence of celebrities and heightened media activity. Wheaties and the evangelical organization Athletes in Action sponsored a "prayer breakfast." And pseudo-events were staged when outsized Coca-Cola cans, the Pillsbury Doughboy, and Green Giant's Little Green Sprout strolled the airport and the skyways of Minneapolis. In a show of media savvy, MTV veejay "Downtown Julie Brown" appeared at NFL media day at the Metrodome and became an event herself.

Events and pseudo-events were staged for media consumption, offering cameras a ready-made strategy for reportage. The promise of food, comfortable transportation, and entertainment enticed reporters and photographers to attend even the most banal and ridiculous happenings. Printed schedules distributed to members of the press upon their arrival provided an agenda for the week's work, camera-worthy events certain to promote the conviviality offered by the Super Bowl and Minneapolis-St. Paul.

PERSONNEL Personnel involved in Super Bowl activities were uniformed by organizers, offering a consistent, orderly look and sometimes, explicitly promoting a product. Waiters and waitresses at banquets, fund-raisers, and corporate luncheons and dinners were formally attired for the occasion in crisp white shirts and black bow ties, with black slacks or skirts. Elderly volunteer "ambassadors" were strategically stationed throughout the city to provide information to visitors; all wore tidy blue knit shirts, with "hot host" buttons pinned to their chests. Vendors selling souvenirs wore Super Bowl T-shirts, and models at the Bud Bowl were clad in BUD WEI SER T-shirts, commodifying them like the beer they promoted. At the site of every Super Bowl

activity, uniformed security guards patrolled the perimeters, protecting participants, eyeing oglers, and expelling trespassers. Cheerleaders beautified themselves to live up to the expectations their eye-catching costumes encouraged. Their identities and roles defined by their uniforms, Super Bowl personnel adopted appropriate behaviors and attitudes.

There would be no mistaking service Super Bowl personnel, their availability marked by their attire. In this way the population was neatly partitioned. The resultant appearance of order and efficiency paid tribute to the organizational skills of planners, and reified the status hierarchy, visually reaffirming the privilege of Super Bowl guests and the subjugation of the host community.

PARTICIPANTS Visitors, like the personnel hired to serve their needs, wrapped themselves in the symbols issued by corporate elites. In some instances, enlisting the compliance of participants required nothing more than a give away. All who attended the aerobic workout received a complimentary T-shirt covered with the logos of local corporations. Kids attending the football clinic were given shirts designed by the manufacturer of a popular style of casual attire. Adopting their teams' symbols, football fans costumed themselves in Indian headdresses made from chicken feathers, masked their faces in hogs' snouts, or wore buffalo sunglasses. Symbols of wealth shared the scene as limousines clogged the streets, whisking fur-coated passengers from site to site. At one lavish party I attended, guests who came unprepared could borrow or purchase a fur coat from the well-stocked racks made available by Alaskan Furs.

Protests mounted by the American Indian Movement took aim at racism in sports, opposing the use of "Redskins" as a team name and mascot. Rather than target poverty or homelessness—problems plaguing the Native-American community in Minneapolis— protest organizers chose to exploit the presence of the media to raise consciousness about the offensive use of symbols. Patterned after the format of the NFL Super Bowl logo, the American Indian Movement created and sold "Stupid Bowl" T-shirts. In our photographs, unless closely scrutinized, they look like the NFL-licensed T-shirts sold internationally, and images of protest seem to offer an ironic twist. All who populated the site of the Super Bowl could be distinguished according to the symbolic markers they assumed, voluntarily or by decree. Protesters could be differentiated by their behavior, their placards, and their attire, providing a disorderly counterpoint to the patina of sophistication and aura of celebration promoted by event organizers and taken up by participants. Because they too had their place in the spectacle, accommodated by the system they accused of injustice, protest could be used to offer evidence of the privileges we all share as citizens.

TOWARD RE-SYMBOLIZATION As photographers and ethnographers, our goal in chronicling the Super Bowl was to understand its inherent meaning and to share what we learned through the publication of pictures. Aware of the intense boosterism surrounding the Super Bowl, we hoped to take a more penetrating look at the unfolding spectacle and produce an independent interpretation of the events we witnessed. One of the points most clearly driven home by this experience regards the complicity and responsibility of the photographer assumed in the act of representation.

Contract

Quixotic as it must have seemed, in 1982 an optimistic Governor Rudy Perpich embarked on a quest to bring the Super Bowl to Minneapolis, creating the Minnesota Super Bowl Host Committee to help fulfill his mission. He appointed Marilyn Carlson Nelson, daughter of travel industry mogul Curt Carlson, and senior vice president of Carlson Holdings, Inc., to chair the group. Nelson assembled a team of politicians and CEOs who shared the governor's dream to sell Minnesota to the NFL. Together they vied for the chance to bring home the nation's premiere promotional vehicle, and with it an opportunity to catapult Minnesota into the national spotlight.

The committee aggressively lobbied NFL owners, who preferred spending January on warmer turf, in places like Miami, New Orleans, or San Diego. In order to woo the owners, the committee faced a dual task: to present an economically compelling proposal and to conjure up an image of Minnesota as an attractive venue for Super Bowl activities, despite the cold winter weather. NFL bid prerequisites included two covered practice sites and 22,000 guaranteed hotel rooms, 12,000 within the host city itself. The committee also had to demonstrate a "clear public and private commitment" to the Super Bowl—in other words, access to public and private monies. According to Marilyn Carlson Nelson, "That meant at least a $3 million budget."

All of the cities competing to host the Super Bowl offered attractive financial packages, so bidders devised additional persuasive strategies. Bid cities routinely showered NFL team owners with expensive gifts. The Minnesota committee distinguished itself from competitors by adopting a duck theme to promote the state. Perhaps they chose ducks to suggest Minnesota's many lakes—all of which would be frozen in January. They presented NFL owners with chocolate ducks, duck-festooned beach towels, and duck slippers, and placed rubber duckies bearing the slogan "Come play indoors in

Minnesota" in the bathtubs of NFL owners' hotel rooms. A former Miss America contestant worked the hotel meeting rooms dressed in a yellow duck costume.

Despite Minnesota's attempts to make a clever pitch, southern cities repeatedly bested the Minnesota delegation, until Mike Lynn, general manager of the Minnesota Vikings, persuaded the NFL owners to hold the Super Bowl in a northern-tier city at regular intervals. The owners agreed to schedule the 1992 game in the North, returning once every seven to eight years thereafter. With this new policy in place, after four unsuccessful bids, Minnesota presented a successful package. Governor Rudy Perpich proudly outlined the key features of the winning bid:

1. Perfect 72-degree temperature inside the Humphrey Metrodome.

2. Rent-free use of the Metrodome during Super Bowl week.

3. More than 11,000 first-class hotel rooms within 15 minutes of the Metrodome.

4. The Minnesota Vikings will waive their rights to some 4,500 tickets, effectively increasing the number of seats available to the NFL by that number.

5. Each NFL team will receive one free suite in the Metrodome, a free first-class hotel suite and full use of a limousine during their stay.

6. We have met or exceeded all NFL hosting requirements. In addition, we pledged in Washington an incentive payment to the NFL of some $1,500,000, making the total value of our package some $5,332,300, second only in value to the Rose Bowl.[1]

In May 1989, the NFL Site Selection Committee chose Minnesota over Detroit, Seattle, and Indianapolis on the sixth ballot.

What motivated local power elites to join forces, pooling their expertise and resources in pursuit of the Super Bowl? Why do cities pledge millions of dollars to compete for the privilege of playing host? Short-term economic gain seems the most obvious answer, but an added enticement lures the corporate elite: the belief that big events like the Super Bowl leave a profitable legacy of urban growth. In their study of the political economy of the city, John Logan and Harvey Molotch assert that urban growth "can increase aggregate rents and trap related wealth for those in the right position to benefit." Logan and Molotch demonstrate how economic elites use the positive values associated with urban expansion to shape local decision-making in ways that enhance their own wealth and status. Logan's and Molotch's description of cultural institutions involved in the growth apparatus includes "the blue-ribbon committee that puts together local spectaculars," coalitions like the Minnesota Super Bowl Host Committee. Special events "show off the locality to outsiders who could generate additional investments in the future." While the benefits of urban growth accruing to local elites can be convincingly demonstrated, the advantages that trickle down are more difficult to ascertain, especially when weighed against the costs shouldered by the public.[2] The Super Bowl machinery set in motion by the Twin Cities' corporate elite offers a case in point illustrating the social dynamics Logan and Molotch describe.

After winning the bid, the Super Bowl Host Committee evolved into the Minnesota Super Bowl XXVI Task Force, a "non-profit organization comprised of 78 prominent Minnesotans." The membership read like a "who's who" of Minnesota's corporate and political elite, individuals well positioned both to plan and benefit from the impending event. Marilyn Nelson had already proved an able leader, marshaling the resources and skills availed by her vice presidency in Carlson Holdings. Her success as host committee chair segued into the chairmanship of the burgeoning Super Bowl XXVI Task Force. Subcommittees mushroomed, devoted to everything from compliance with NFL regulations to community hospitality, and local corporate leadership stepped forward to assume command. CEOs from Twin Cities advertising and public relations firms, media corporations, retailers, and restaurateurs guided the planning process, while the governor, U.S. senators, Twin Cities mayors, and a handful of local politicians were welcomed aboard as members of advisory committees.

The task force launched a national search for an executive director to manage the growing Minnesota Super Bowl bureaucracy. For her lieutenant Nelson chose Paula Gottshalk, a corporate and marketing communications consultant and former vice president for corporate information at CBS. Among Gottshalk's key responsibilities, according to a task force press release, would be "budgeting, fundraising and marketing Minnesota and the Twin Cities." Gottshalk presented sterling qualifications, and Nelson affirmed her selection offering the media this quote: "There were several outstanding candidates, but Paula's impressive corporate background and her experience in handling large-scale events and working with the media made her the number one choice."

The Minnesota Super Bowl XXVI Task Force set to work, focusing their collective expertise to fully exploit what they called the "free" publicity provided by the Super Bowl. Bill Dunlap, chair of the marketing committee and CEO of Campbell-Mithun-Esty, led the effort, marketing the state "just as he would a product." The committee developed a unifying theme with which to promote "Minnesota, host to Super Bowl XXVI," a theme intended to substitute an image of warmth and vitality for frozen tundra.

They launched the campaign at Super Bowl XXV in Tampa. A task force news release unveiled the promotional scheme: "'The Great Minnesota Warm-Up: The Hottest Weeks of the Year' will be used to carry the message that there is a great deal to do in Minnesota in January whether you want to enjoy the outdoor winter experience or prefer indoor activities." A thirty-second spot scheduled to run in Tampa Stadium during the second half of the game was designed to answer the question, "How Hot Will It Get In Minnesota Next January?" The answer, according to the video: "Really Hot."

The task force mobilized additional forces: "Team Rollerblade, the performing group of Minnesota-based Rollerblade Inc., will be representing the state at a number of prestigious events during Super Bowl week. . . . Team Rollerblade is choreographing special routines which convey the 'hot' message and, at the same time, incorporate the football theme. Their uniforms will feature The Great Minnesota Warm-Up theme line as will the banners. . . . which will be prominently displayed in conjunction with each performance."

Key committee members fanned out to jump-start the promotional apparatus. In the NFL

NEWS RELEASE
Minnesota Super Bowl XXVI, Inc.

Super Bowl XXVI To Improve Balance Of Trade For Minnesota

Super Bowl XXVI, scheduled for the Hubert H. Humphrey Metrodome on January 26, 1992, will be of immense positive economic benefit to the State as a whole and, in particular, to the Twin Cities Metropolitan Region. According to a study commissioned by the Minnesota Super Bowl XXVI Task Force and conducted by University of Minnesota economist Wilbur Maki, the event will bring more than $2,000,000 in sales and sales-related taxes to the State Treasury and $47,000,000 from direct spending into Minnesota in the first quarter of 1992, a traditionally slow period for the Minnesota economy. These are dollars earned outside the State and spent in Minnesota.

The Super Bowl will bring over 58,000 out-of-town visitors to the area for the game. In addition, it is anticipated that as many as 6400 visitors, who will not be attending the game, will be drawn to the State because of Super Bowl activities. In all, nearly 70,000 visitors will be in the area to take part in the festivities surrounding the game.

Each visitor is expected to spend an average of $170 per day, or nearly $30,000,000 total over a stay of 2.5 days. Even if none of the anticipated 6400 visitors without tickets materialize, direct benefits would still total more than $27,000,000.

Construction and pre-game preparation expenditures would add another $17,000,000 to the direct spending total of nearly $47,000,000. That's $47,000,000 that otherwise would not have been spent in the State. These figures are in 1990 dollars. Factoring in the projected inflation rate of 4% per year, the 1992 direct revenue from the Super Bowl increases to more than $50,000,000.

The direct benefits to Minnesota would include state sales, motor fuels, alcohol and tobacco products tax revenues totaling $1,600,000 in 1990 dollars. Additional individual and corporate income taxes collected in the next year from the economic activity generated by Super Bowl XXVI would add as much as $700,000 more to state revenues.

New business generated by Super Bowl XXVI visitors will bring new dollars to the State which will circulate and recirculate, thus creating a multiplier effect on the state economy. A conservative estimate of total economic activity would exceed $100,000,000 and be as much as $110,000,000, including visitors who will not be attending the game.

media center at Tampa's Convention Center, task force members staffed a Super Bowl XXVI booth, making printers available to sportswriters and offering computer repair service and backup typewriters in case all other efforts to be helpful failed. Minnesota-based General Mills Corporation's Pop Secret Popcorn and apples were on hand. Once a reporter had been snared, the task force took advantage of the opportunity to tell the "Minnesota story." Other task force members inserted Minnesota Super Bowl brochures into stadium seat cushions on game day, while some committee members observed the activities of their Tampa counterparts to learn the ropes in advance.

A primary target audience for task force promotions were the "corporate hospitality and travel incentive planners" representing major corporations and travel agencies nationwide. In order to coordinate their own planning efforts with the needs and preferences of travel planners, the task force scheduled focus-group meetings with them during Super Bowl XXV, listening carefully to this important constituency. In the spring the task force flew more than ninety travel planners to the Twin Cities for a "familiarization tour," showcasing what the city could offer: its restaurants, entertainment venues, museums, and sports facilities. A trade show promoted local vendors, who were given an opportunity to display their goods and services. Representatives for such corporations as Eastman Kodak, Coca-Cola, Sony, Sports Illustrated, Phillip Morris, USA, Merrill Lynch, Chrysler, Coors Brewing, Miller Brewing, and General Electric received invitations to attend another focus group meeting at the end of the tour to help the task force fine-tune their conclusions.

A few weeks later the annual meeting of NFL team owners was held in Minneapolis, providing another opportunity to showcase the state. Members of the task force staffed a "hospitality desk" for the owners where they dispensed information about the city, made restaurant reservations, and acted as conduits with NFL staff. The task force invited team owners to a reception held in their honor at Pillsbury's corporate headquarters in downtown Minneapolis. The site was strategic, enabling select members of the task force to give the owners a tour of the temperature-controlled skyway system en route to and from their accommodations at the Radisson Plaza Hotel. Lest they themselves should lose their way in the maze of skyways, an internal memo admonished staff, "Remember to walk the route again if you are at all unsure of how to get there!"

As the 1991 football season drew to a close, the task force turned its attention to selling the Super Bowl to the rest of Minnesota. To facilitate this assignment the task force commissioned University of Minnesota economist Wilbur Maki to forecast the economic impact of the Super Bowl on the state, and the professor's study became an instrumental part of the task force sales pitch. Armed with Maki's numbers, the task force addressed business leaders and politicians in boardrooms and meeting rooms, preaching the economic advantage the Super Bowl would deliver to all Minnesotans. Professor Maki himself presented the data at some meetings, balancing the zeal and exuberance of the task force with his scholarly authority.

The local "hospitality" industry—an inviting euphemism encompassing the industries associated with travel—would be the immediate beneficiary of the Super Bowl. Not coincidentally, Carlson Holdings and its heir apparent, Marilyn Carlson Nelson, commanded an especially opportune position. With its international chain of travel

Celebrity Autograph Party

Every Super Bowl draws a large number of NFL players, NFL alumni and celebrities. The potential exists for a company to host a fantastic party for the community featuring these sports stars and idols. Experience shows that an Autograph Party would be a major draw in this area.

The Autograph Party may be at one centralized site or in a variety of locations, depending on the sponsor's wishes. The ultimate cost of this package depends on the number of players, NFL alumni and celebrities wanted and the honorariums needed for each.

The presenting sponsor will receive exposure with its name in the event title as well as signage at the party. There is also opportunity for the sponsor to feature product at the event-for example, autographs would be collected on the visor of a cap or on pictures-or for product giveaway.

Sponsor Benefits:

· Sponsor name in event title
· Sponsor signage at the Autograph Party
· Mention in press releases about Super Bowl Week events
· VIP tour for 2 of NFL Media Center in Media Headquarters on Saturday, January 18, 1992
· VIP tour for 4 of Metrodome during rehearsal for Super Bowl XXVI half-time show
· 2 tickets to Host City Media Party
· 10 complimentary tickets to invitation-only community event, if held
· Mention on Metrodome scoreboard during each Minnesota Vikings '91 season home game
· Listing in contributor recognition crawl on 10 media walls in the skyway system
· Host City Super Bowl XXVI logo merchandise discount of 25% off retail
· Listing on sponsor page in Host City Brochure of which at least 100,000 will be distributed during Super Bowl week
· Listing in Thank You ads in the Minneapolis Star Tribune (circ. 413,000) and Saint Paul Pioneer Press (circ. 198,000) scheduled to run immediately following Super Bowl XXVI
· Listing on Task Force page in a Skyway News publication (distribution 340,000) during Super Bowl Week
· Listing on Minnesota Super Bowl XXVI Task Force page in Minnesota Vikings Game Day program throughout the 1991 season
· Mention in our Hotline newsletter which reaches 5000-plus key decision-makers including the CEO's of Fortune 500 companies as well as Minnesota's top 200 private and public companies
· Invitation to remaining Minnesota Super Bowl XXVI "Chalk Talks" to update contributors, sponsors, hospitality industry, volunteers, etc., on plans for Super Bowl Week

Sponsorship: $50,000 + talent

agencies, its eight Radisson Hotels, and several T.G.I. Friday's restaurants in the Twin Cities area alone, the travel, resort, and restaurant divisions of the company were poised for an exceptional January windfall. And if the professor's forecast proved accurate, after the snows melted CEOs and citizens alike would continue to benefit from the economic activity generated by the Super Bowl, "new dollars...which will circulate and recirculate" through the state's economy, as well as revenues produced by the increased corporate and individual income taxes predicted to swell state coffers.

The Maki study presented a portrait of profit so compelling the task force itself could hardly have improved upon it. Not surprisingly, published research contesting Maki's assertions never surfaced. Even the few anti-establishment reporters who wrote articles questioning the task force gospel failed to use the available data to support their critiques. Logan and Molotch cite several studies suggesting that elites routinely attempt to gain support for plans that advance their own economic interests by minimizing public costs and exaggerating public benefits. They write, "The short-term results of big events can mean billions of dollars injected into the local economy, although costs to ordinary citizens (in the form of traffic congestion, higher prices, and drains on public services) are notoriously understated. To help gain the necessary public subsidies for such events, the promoters insist that 'the community' will benefit, and they inflate revenue expectations in order to make trickle-down benefits at least seem plausible."[3] Presented in the guise of disinterested scholarship and unchallenged by disconfirming data, Maki's report provided the task force with a potent tool.

The task force parlayed anticipated income, immediate and deferred, to build the support of local corporations, even those with nothing tangible to sell. The "Super Bowl XXVI Speech" presented to leading Minnesotans pledged: "We're taking every opportunity to showcase Minnesota as a thriving business community that is technically sophisticated, economically strong, and a desirable travel destination." In order to maximize the future benefits foretold by Professor Maki, task force members urged their peers to work together to "deliver a great Super Bowl." Then came the pitch: "As you all know, it takes money to make money. . . ."

In a city known for its corporate philanthropy, business leaders recognized Marilyn Carlson Nelson's position among the ranks of the local philanthropic elite. With Nelson at the helm, the task force leadership was well rehearsed at mobilizing the corporate community to make donations to its own pet causes. In his case study of the Twin Cities' grants economy, sociologist Joseph Galaskiewicz outlines the system of rewards and sanctions used by core Twin Cities elite in order to influence local corporate giving. Galaskiewicz found that "those who refused to contribute often lost respect among business leaders or were denied access to local civic culture. These forms of reward and punishment were part of the elite's duties. To the extent that members of the elite controlled the intangible selective incentives of recognition, esteem and respect, they acted as social or status gatekeepers in the business community."[4] Nelson knew what buttons to push in order to produce the desired response, and in the Super Bowl speech she preached the gospel of imminent economic growth and appealed to potential donors' concern for the well-being and contentment of their community. Through their participation, companies earned the recognition of their peers as team players and successful business enterprises. As they came on board, ads listing sponsors and their

level of largesse appeared in local newspapers and task force brochures, publicly announcing their goodwill.

Based on its earlier reconnaissance the task force had already contrived a variety of sponsorship venues that would infuse the city with a "party atmosphere" and provide a promotional vehicle for donors. "Dayton Hudson Department Stores has signed on as the sponsor of our Ambassador Program. Target is sponsoring what we call our Host City Brochure—the 'bible' for Super Bowl week events and activities as well as our street banners. They've also given us thousands of amenities to give to special visitors. Jostens is sponsoring a media party. . . . KS95 is the sponsor of a Quarterback Toss which will be in two of the major Minneapolis skyway atriums. Contestants will try to project a football through a big KS95 sun logo. Participants with successful tosses will become eligible to win a new car or boat." After the task force recited a list of corporations that had already joined the team, they outlined opportunities for participation, such as delivering groups of volunteer workers culled from enthusiastic employees.

In exchange for their sponsorships, CEOs received a "benefit" package—the larger the gift the more elaborate the package. Early in the game, a handful of companies had contributed start-up money to the task force. They were termed "benefactors" and received Metrodome suites for the Super Bowl, as well as options to purchase additional tickets, a benefit made possible through "the generosity of the Minnesota Vikings." By autumn such lavish benefits had evaporated and the fund-raising speech delivered in November carefully disabused the audience of the notion that the task force had Super Bowl tickets available. In return for their gifts, subsequent contributors received such perks as tickets to the Host City Media Party, rights to purchase tickets to a "star attraction" concert, publicity in task force publications, and the right to emblazon banners, signs, and uniforms with the corporation's own logo.

As the Super Bowl approached, the task force could take credit for several victories. They had succeeded in selling Minnesota to the NFL, to travel planners, and to the Minnesota business community. They were selling sponsorship packages for the events they had organized. Their extensive efforts to plan "the best ever Super Bowl," an event that would showcase the sophistication of the state and its friendly, dedicated workforce, seemed to be coalescing. All that remained was to convince dubious residents, especially the inhabitants of "Greater Minnesota," that their tax dollars were being wisely spent, and that the much-ballyhooed economic benefit would indeed trickle down and pool up in their pockets.

Despite the expert salesmanship of the task force, one group seemed impervious to their pitches—the American Indian Movement, headquartered in Minneapolis. Primed by the 1991 World Series bout between the Minnesota Twins and the war-chanting, tomahawk-chopping Atlanta Braves, AIM prepared for a second round of protests in Minneapolis. The Redskins' appearance in the Super Bowl was especially opportune; the sight of fans decked out in chicken-feather headdresses would illustrate AIM's contention that the use of Native Americans as team mascots and emblems is inherently racist. AIM scheduled the "National Summit on Racism in Sports and the Media" during Super Bowl week to draw additional attention to their cause. The NFL and the Super Bowl XXVI Task Force responded swiftly and scheduled a meeting and luncheon at which representatives of local

minority communities were offered "an update on important business opportunities that have been extended to minority-owned companies in the Minneapolis/St. Paul area" as a result of the Super Bowl.

While corporate mouthpieces continued heralding Super Bowl profits, most local minority-owned businesses waited for service contracts that failed to materialize. Despite the efforts of the task force to bring minority-owned businesses to the attention of the NFL and travel planners, only seven of more than one hundred contracts awarded locally were obtained by minority-owned firms.[5] Although the Maki report predicted an upsurge of employment opportunities resulting from the Super Bowl, Dan Nicolai, a writer for the Surveyor, a community newspaper covering the inner-city neighborhoods adjacent to the Metrodome, predicted that few residents of low-income neighborhoods would be offered jobs in conjunction with the Super Bowl.[6] Gary Gardner, president of the inner-city Elliot Park Business and Professional Association, expressed similar skepticism in an article appearing in the Minneapolis Star Tribune: "I would be surprised if it brings $50 into the neighborhood. The trickle down theory means the neighborhood gets dumped on."[7]

These inner-city leaders offered their own unschooled rejection of the task force's promise of increased employment, disclosing justifiable doubts supported by Logan's and Molotch's research: "The reality is that local growth does not make jobs: it only distributes them."[8] The data they cite contradict the assertion that a one-time event like the Super Bowl delivers new jobs; urban growth promoters more often employ this myth than the workers for whom its persuasive effect is intended. Rather than providing jobs for the unemployed residents of a given locale, urban growth stimulates migration among job holders, shifting them from one place or position to another. The economically disadvantaged reap few, if any, of the rewards suggested by the Maki report. According to Logan and Molotch, "local growth may be only a matter of making the local rich even richer, or, alternatively, of moving those already privileged in their jobs from one part of the country to another part of the country."[9]

Attitudes like those expressed by Nicolai and Gardner surfaced like unattractive blemishes spoiling an otherwise flawless facade, and they jeopardized the appealing image of Minnesota the task force banked on. The task force soft-pedaled skepticism, disparaging these brusque locals as cranks who were putting a damper on local enthusiasm. To engender community spirit and quell dissonant voices the Minnesota Super Bowl XXVI Task Force approached the local public as it had the NFL team owners. As Marilyn Carlson Nelson had testified, "a traditional part of a bidding city's presentation was to lavish expensive gifts. . . . on the NFL team owners," so-called "amenities." Similarly, the task force concocted a give-away for the local public: "The Great Minnesota Warm-Up Weekend." It was offered as Minnesota's unique opportunity to take part in the fun and festivity of the Super Bowl during the weekend before the arrival of the Twin Cities' "out-of-town guests."

In a demonstration of sincerity, Nelson led an entourage of task force representatives in a "flyaround" the state to invite residents to come to the Twin Cities. At each stop, an appearance by local officials anchored the message in the community. An internal task force memo provided the script, complete with stage blocking: Marilyn introduces team. Others stand behind. Where there is no podium, person speaking will sit at microphones,

Others will stand behind. "We want Minnesotans to be *first* to experience the fun and excitement of the activities surrounding the Super Bowl." The list of task force-planned events followed: the Warm Up.... Workout, the Celebrity Autograph Party, the Party Under Glass, the NFL Classic Alumni Game, and a football clinic for kids. And there were added enticements: activities were free or inexpensive and designed for families; hotel rooms were plentiful and some offered discount packages.

Years of concentrated effort and millions of dollars later the Minnesota Super Bowl verged on realization. Consummate deal-makers, the task force had negotiated an ambitious contract with the NFL and with the public. Enabled by their corporate affiliations, they mobilized vast resources to plan and implement a week of festivities that would proceed like clockwork no matter the weather (the one variable remaining beyond their collective grasp). But winning the consent of the community proved the most masterful of all these accomplishments. Leveraged by the contestable assertion that the Super Bowl would be an economic boon to the entire state and benefit all its residents, the task force commandeered millions of dollars in public and private funds and harnessed the labor of thousands of paid employees and volunteer workers. Only one outcome could be forecast with certainty: the Super Bowl would be a bonanza for Minnesota's corporate elite, the real constituency of the task force.

NOTES

[1] *Minnesota Super Times: A Publication of the Super Bowl Task Force*, 1985.

[2] John R. Logan and Harvey L. Molotch, *Urban Fortunes: The Political Economy of Place*, University of California Press, 1987, p. 50.

[3] Ibid., p. 78.

[4] Joseph Galaskiewicz, *Social Organization of an Urban Grants Economy: A Study of Business Philanthropy and Nonprofit Organizations*, Academic Press, Inc., 1985, p. 226.

[5] Eric T. Pate, "Minority-owned businesses see empty Bowl." *Star Tribune*, Jan. 25, 1992, p. 15A.

[6] Dan Nicolai, "Will local jobs trickle down?" *The Surveyor*, Nov. 1991, p. 1.

[7] Kevin Diaz, "Few Super Bowl benefits seen in neighborhoods." *Star Tribune*, Jan. 9, 1992, p. 1A.

[8] John R. Logan and Harvey L. Molotch, loc. cit., p. 89.

[9] Ibid., p. 93.

A Narrative Note:

These symbols mark commentary compiled and edited from diaries kept by several photographers whose images appear in this book.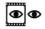

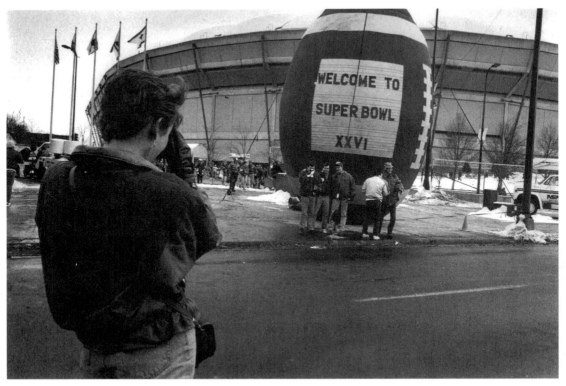

One of the many giant inflatables visible throughout the city inspires a commemorative snapshot.

In mid-January we embarked on our mission to document the spectacle about to unfold in our hometown. After years of exposure to the Super Bowl, refracted through the lens of the mass media, we thought we understood the event. Inside the Metrodome the Washington Redskins and the Buffalo Bills would vie for the NFL championship. But the football game was merely a backdrop for the real contest taking place in the hotels, shops, and restaurants of the Twin Cities—the competition for economic advantage, waged on the well-groomed playing field of free-market capitalism.

NEWS RELEASE
Minnesota Super Bowl XXVI, Inc.

MINNESOTA SUPER BOWL XXVI MISSION STATEMENT

A. To set a new standard in Super Bowls by creating and delivering the most innovative, exciting and well organized week of activities in the event's history--thus insuring that a Northern tier city continues to be part of the Super Bowl Host City rotation.

B. To seize the opportunity to showcase our thriving business community with emphasis on its technical sophistication, economic strength and global networking as well as to assure Minnesota's rightful place as a major travel and convention destination.

C. To provide a positive experience and opportunity for involvement for all members of the Minnesota community with special emphasis on involving them in the party week itself.

D. To raise dollars for a cause thus making Super Bowl XXVI a "Party with a Purpose."

E. To treat local, national and international media as VIPs encouraging them to report the Minnesota story and aid them in this process.

F. To develop a marketing plan and an exciting week of activities which entices potential ticket holders to schedule a stay of three or four days in the area.

G. To plan or promote a major activity or event in each city in the metropolitan area, and in doing so, create a sense of pride in the dynamism of the entire seven-county metro area and state of Minnesota.

H. To make everyone in Minnesota proud to have been host to America's foremost professional sports competition.

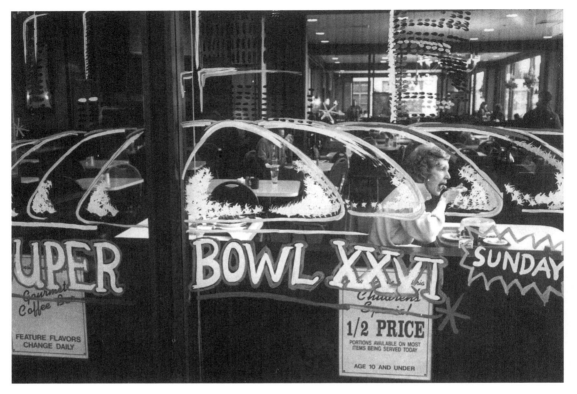

An image of the Metrodome, painted on the window of a skyway lunch spot, welcomes Super Bowl visitors.

The Twin Cities were transforming in front of our eyes. In downtown Minneapolis, Super Bowl banners hung from every lamppost, bearing the corporate insignia of its sponsor, Target. Coca-Cola USA's logo appeared on newly installed direction signs posted throughout the skyway system. Rooftops were sprouting giant inflatable Budweiser, Miller, and Coke cans. Likewise, local entrepreneurs competed for visitors' dollars by decorating their businesses with Super Bowl regalia. Minneapolis had become a Super Bowl theme park, poised for the influx of capital.

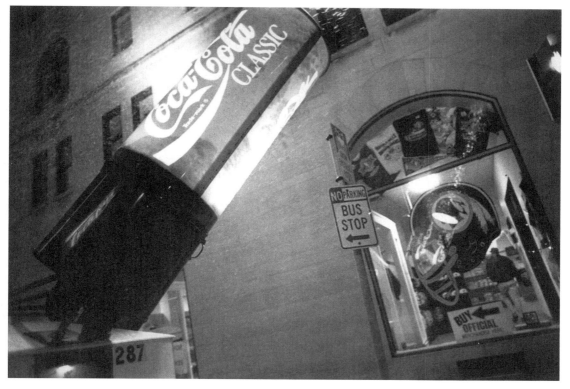

Throughout Minneapolis, gyrating Coca-Cola spotlights traced the evening sky.

PAUL TAGLIABUE, COMMISSIONER, NATIONAL FOOTBALL LEAGUE

"The Super Bowl also means opportunities for local businesses. Our plans ensure the economic participation of the great people of Minnesota, including those representing minority groups."

YUSEF MGENI, PRESIDENT, MINNEAPOLIS URBAN COALITION

"Some people say a rising tide raises all ships. But what does a rising tide do for the people wearing cement shoes?"

SPORTS TEAM MASCOTS RESOLUTION

WHEREAS, Many sports teams, university, and schools have Native American
 mascots and emblems such as the following:

 Washington D.C. Redskins (Football)
 Atlanta Braves (Baseball)
 Kansas City Chiefs (Football)
 Cleveland Indians (Baseball)
 University of Illinois Chief Illinawek

WHEREAS, it is racist and demeaning to use a group of people such as
 Native Americans as a mascot while animals like dalmations etc.
 are mascots for firehouses in other situations;

WHEREAS, team members, sports fans, mascots, and the media in the name
 of profits, team pride and loyalty use negative stereotypes to
 portray Native Americans and abuse cultural traditions
 and dress;

THEREFORE, BE IT RESOLVED that the National Women's Conference Committee
 take a position opposing the use of Native Americans as team
 mascots and emblems.

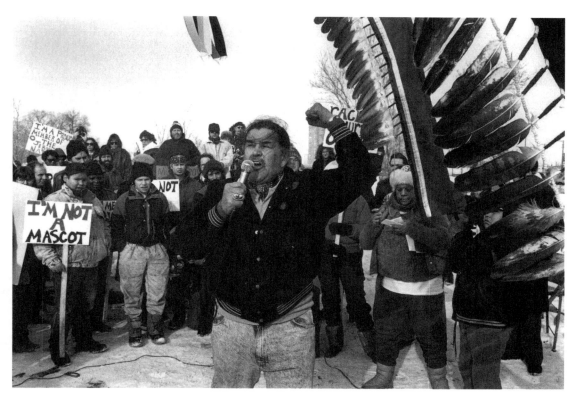

Clyde Bellecourt of the American Indian Movement leads a demonstration protesting racism in sports.

Dear Mr. Bellecourt:

On behalf of National Football League Commissioner Paul Tagliabue, I am pleased to invite you to attend a meeting and luncheon on Thursday, January 9, 1992, at the Hyatt Regency, 1300 Nicollett Mall, Minneapolis, to discuss Super Bowl related minority affairs.

I would like to provide you and other leaders in the various minority communities with an update on important business opportunities that have been extended to minority-owned companies in the Minneapolis/St. Paul area. The meeting will also provide an opportunity for you to express any minority-related concerns directly to the National Football League. Representatives from the Minneapolis Super Bowl Task Force will also be in attendance. . . .

I look forward to seeing you on January 9.

Sincerely,
David Cornwell
Assistant Counsel and Director of Equal Employment

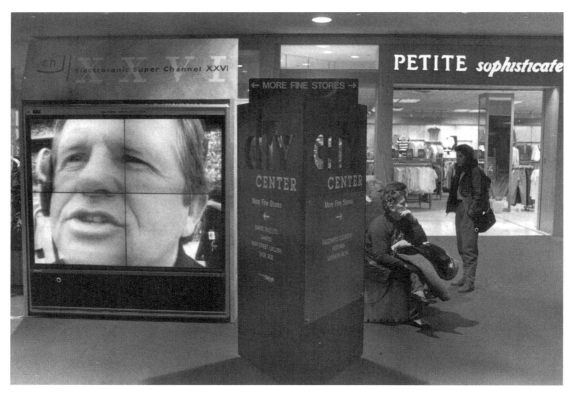

An Electrosonic video wall, up and running at the City Center retail complex in Minneapolis, broadcasts nonstop NFL highlights.

Camera at the ready, I combed the city to find—what? I didn't yet know exactly what I was looking for—whatever might increase our understanding of the Super Bowl experience. I kept alert for symbols I could wrest from event planners and bend to my own particular acquisitive intentions. In the distance a flickering screen beckoned; the sounds of grunting athletes crashing into one another penetrated the predominately female domain of the shopping mall. I drew closer to examine this curious monolith and witness its peculiar testimony to the legacy of NFL football. Larger than life, the men onscreen played to an empty arena. Its invitation to pay tribute went unnoticed by the women in search of January bargains. Surely when the out-of-town fans arrived I would be able to find those who knew what rites it was designed to animate. Collecting an image and filing it away for future scrutiny would have to suffice for now.

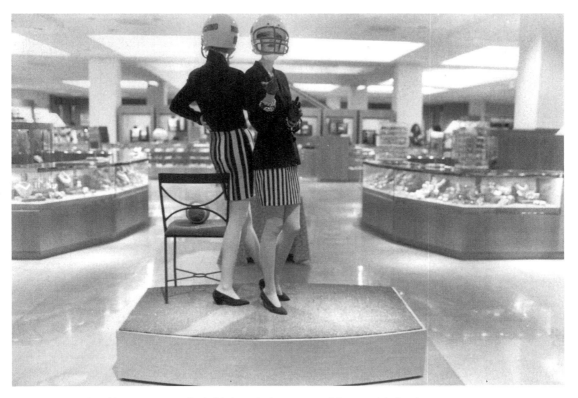

Mannequins at Saks Fifth Avenue sporting football helmets beckon Super Bowl fans a week before the game.

Stewart Widdess, senior vice president of marketing at Dayton's has chaired a Super Bowl Committee focused specifically on a strategy aimed at getting visitor spending in the Minneapolis downtown. His committee has created skyway system entertainment for all day Saturday and Sunday morning. The idea is to get potential customers into the system, and then into stores and restaurants.

Widdess thinks indoor entertainment will work at attracting shoppers, specifically because the Super Bowl crowd will avoid the cold by staying in cozy skyways and stores.

Many retailers are teaming up with hotels to get their stores noticed. Dayton's will be placing invitations for free makeup applications on hotel pillows.

Saks has placed "welcome packets" in 2,000 hotel rooms. And while many stores have left their names with concierge services in hotels, Saks is going a step further. It has stationed receptionists in some hotels, who greet visitors and tell them they can get instant charge cards and same-day alterations.

MINNEAPOLIS
STAR TRIBUNE

Besides the general flow of Super Bowl traffic, some stores are catering to special groups. Saks is planning a one and one-half hour special shopping service for a corporate group of 650 customers. Besides refreshments, each will be given one-on-one service and a tour of the store.

"Ambassadors" roamed the skyways, distributing copies of the Minnesota Super Bowl XXVI Playbook *listing local events.*

The skyways connecting offices and retail spaces were converted into billboards advertising the upcoming game. Each bore a huge replica of the Redskins' and Bills' helmets painted on the glass overlooking the streets. When I peered out, the Super Bowl framed all familiar vistas, transforming the cityscape into something new. The Super Bowl XXVI Task Force planned a Party Under Glass that could be contained within the sheltered environs of corporate Minneapolis, protected from the weather and the streetlife below. Musicians, puppeteers, jugglers, and volunteer ambassadors populated the aerial corridors. In the atria of corporate office towers more entertainment awaited. Recently erected sound stages provided a platform for home-grown talent, while contests and pep rallies were scheduled to extend visitors an opportunity for participation. The ubiquitous video walls provided an ever-present backdrop that asserted the significance of football. Prominently displayed logos showed that corporate gifts made the party possible. Never before had our city appeared so dynamic, never before had I seen so many helpful, smiling people poised to make their own personal contributions. I wondered what other causes could have elicited such an outpouring of energy, enthusiasm, and expenditure.

State of Minnesota
Proclamation

WHEREAS: Minnesotans are a priority in Super Bowl Week Festivities; and

WHEREAS: The Minnesota Super Bowl XXVI Task Force would like Minnesotans to have the opportunity to experience the excitement of Super Bowl Week; and

WHEREAS: The Task Force recognizes that a limited number of Minnesotans will be able to acquire tickets to Super Bowl XXVI; and

WHEREAS: The Task Force, the National Football League and the Saint Paul Winter Carnival have planned and coordinated a variety of exciting events for Minnesotans as an "Insiders' Kickoff"; and

WHEREAS: These events include the Party Under Glass, which is a ten-day-long celebration with prizes, contests, live bands, pep rallies and team fan headquarters in the Minneapolis skyway system; and

WHEREAS: A celebrity autograph party is scheduled for Saturday, January 18, and will feature eight sports celebrities; and

WHEREAS: These events will also include the Super Bowl Warm-Up Workout on January 18, which is an attempt to set the record for the world's largest outdoor exercise event, featuring NFL players and Vikings Cheerleaders and celebrity aerobics instructors; and

WHEREAS: There will also be the NFL Alumni Classic Football Game, a non-contact rematch of the teams that met in Super Bowl VIII, the Vikings and the Miami Dolphins; and

WHEREAS: The Super Bowl XXVI Football Clinic for Minnesota Children, featuring more than 40 players teaching football and sportsmanship fundamentals to groups of Minnesota school children; and

WHEREAS: Super Bowl XXVI should be a memorable week for all Minnesotans;

NOW THEREFORE, I, ARNE H. CARLSON, Governor of the State of Minnesota, do hereby proclaim the weekend of January 17-19, 1992 to be

THE GREAT MINNESOTA WARM-UP WEEKEND in Minnesota.

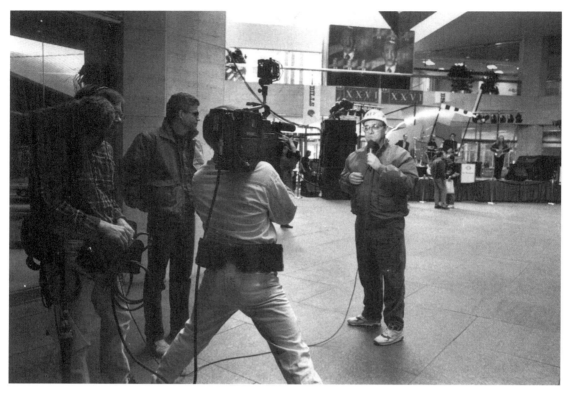

Anticipating the Party Under Glass, National Events Productions films a stand-up at the NFC Fan Headquarters, the IDS Center.

As I explored the stage set crafted from downtown Minneapolis, I repeatedly encountered a mobile film crew, industriously gathering footage for their commemorative videotape. As they moved from place to place they captured emptiness in their lens. I wondered what plans they had for all that footage showing nothing going on. Perhaps they intended, like me, to show the locations where things would soon be happening. Perhaps they planned to use the footage to build dramatic tension, forcing the audience to wait before offering a glimpse of the spectacle and celebrity. I found myself waiting and hoping to find signs that would reveal the ultimate significance of these events, point me to camera-worthy sights, and help guide the direction of my unscripted photo-narrative.

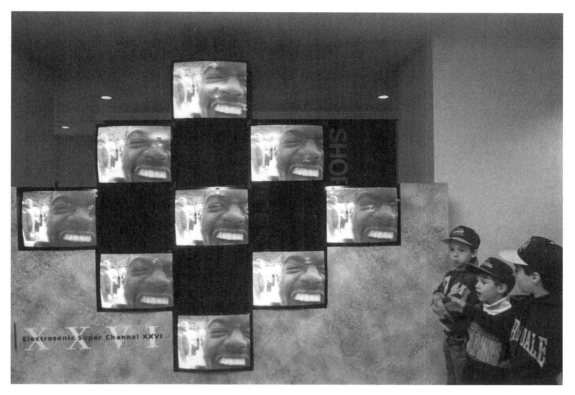

Young sports fans cruising the skyways unexpectedly encounter a recently installed video wall.

News Release

AFC/NFC Champion team fan headquarters, a Celebrity Autograph Party, games, prizes, family entertainment and a "hot" party atmosphere will radiate from Minneapolis' unique and temperate Skyway System starting Friday, January 17 as the Minnesota Super Bowl XXVI Task Force invites all of Minnesota to be the first to enjoy and experience the Party Under Glass. . . .

[T]he IDS Crystal Court and the Pillsbury Center atrium will be transformed into NFC (IDS Center) and AFC (Pillsbury Center) Fan Headquarters, decorated with 50 feet high banners that celebrate the competing Super Bowl teams. Entertainment stages at both locations will feature the diversity and talent of Minnesota musicians in free performances.... Also on Saturday, mimes, jugglers and musicians will stroll through the Skyway System. . . .

Electrosonic Super Channel XXVI, a network of 10 giant media walls created just for Super Bowl Week, will feature NFL Films highlights and be one of the most visible signs of the super look the Skyways will have leading up to Super Bowl XXVI. Another visible aspect of Super Bowl Week will be the four hundred "Ambassadors," dressed in blue polo shirts and red caps, who will help direct party-goers throughout Minneapolis' 34 block Skyway system.

MINNESOTA
SUPER BOWL XXVI, INC.

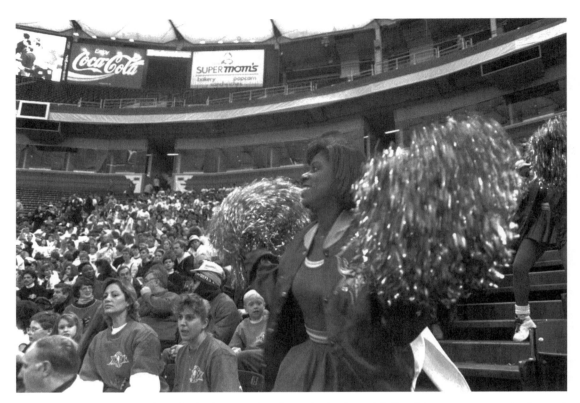

Vikings cheerleaders stream into the stands, chanting and shaking their pom-poms to energize the crowd.

The excitement is palpable; it's a historic moment. The first and "best ever" Minnesota Super Bowl is officially underway. Representatives of the Super Bowl XXVI Task Force uniformed in their specially designed black leather task force jackets take the field and address the crowd.

Marilyn Carlson Nelson, task force chair, and Harvey Mackay, CEO of Mackay Envelope Corporation and author of business memoir Swim With the Sharks Without Being Eaten Alive, *extol the virtues of Minnesota, its citizens, and the NFL. They profess their belief in the value of the Super Bowl, and bestow upon the community their gift—the Warm-Up Weekend. Cheerleaders stream into the stands and rouse the crowd; the music blares, the workout begins.*

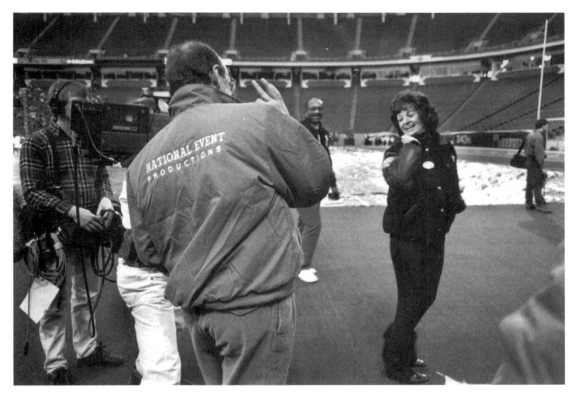

Marilyn Carlson Nelson, chair of the Super Bowl XXVI Task Force, strikes a pose for the National Event Productions crew en route to the official opening of the Warm-Up Weekend.

In October of 1983 former Governor Perpich asked me to form a group of public and private sector leaders in an effort to bring the Super Bowl to Minnesota. Almost nine years later, the dream has become the reality—the eyes of the world will be on the State of Minnesota on January 26. Yes! We are hosting Super Bowl XXVI and all these years later we are more enthusiastic than ever.

As Minnesotans, we recognize a once-in-a-lifetime opportunity to showcase what we know to be true…that Minnesota is a warm, friendly, dynamic place to visit, to live or to do business. Every corner of our community is working to seize this opportunity. We want our visitors to return over and over again.

The Minnesota Super Bowl Task Force has had incredible support from the community!

MARILYN CARLSON NELSON,
HOT LINE: THE OFFICIAL
NEWSLETTER OF THE
MINNESOTA SUPER BOWL
XXVI TASK FORCE

From the onset, hundreds volunteered their time to insure that the Minnesota Super Bowl experience surpasses any other host community effort. Our volunteers have consistently shown the enthusiasm and energy we want to communicate to our visitors. Indeed, those volunteers with hosting responsibilities during Super Bowl Week will be officially called, "Ambassadors." In a sense every Minnesotan will be an Ambassador for our guests and that will make us all proud!

But there is more! We have something just for Minnesotans—an exciting, interesting, literally breathtaking Minnesota, First!

On behalf of the entire Minnesota Super Bowl Task Force, I want to invite you to the Twin Cities January 17-19 for this sneak preview kick off weekend. We want you to show up and show off as participants in a host of exciting events. Please … call for hotel or restaurant reservations. Don't miss the hottest January week in Minnesota history.

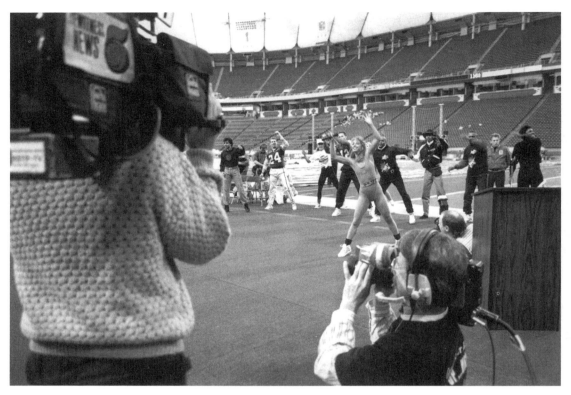

Denise Austen leads a specially choreographed routine while local journalists cover the event for the evening news.

The first scheduled event, the Warm Up ...Workout, had arrived along with frigid temperatures, forcing the event inside the Metrodome. An eager crowd, clad in free T-shirts emblazoned with the names of local corporate sponsors, cheerfully adapted to the constricting space of the stands. As they attempted to follow the choreographed routine demonstrated by exuberant celebrities, the exercisers' knees and elbows knocked into the seats in front of them and the fans working out next to them. Their constrained movements could only approximate the celebrities' vigorous motions on the playing field below.

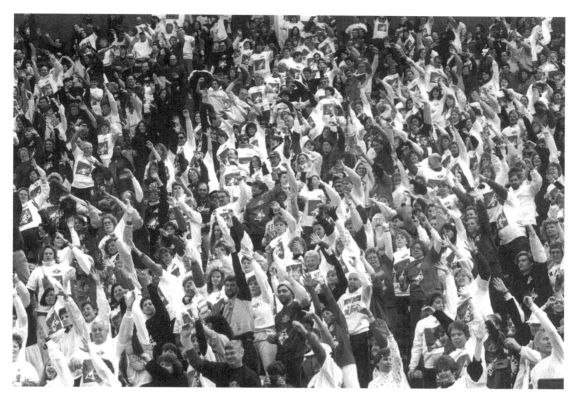

After learning the exercise routine, the cooperative crowd hastily perfomed it outdoors to claim the world record.

News Release

On Saturday, January 18, Minnesotans will join Vikings, Timberwolves, North Stars, Vikings cheerleaders and celebrity aerobics instructors in the "Warm Up...Work Out". Starting at 11:00 a.m., inside the Hubert H. Humphrey Metrodome, participants wil learn a specially choreographed, unique-to-Minnesota aerobics routine. At noon the group will move outside the Dome to perform the workout and try to set a new world record for the largest outdoor exercise event. . . . Leading the work out will be nationally-known aerobic stars Denise Austen, Cory Everson, Gilad and Madeleine Lewis along with the Vikings' Cheerleaders and mascot "Vikadontis Rex," and the Timberwolves' Reebok Performance Team and mascot "Crunch."

MINNESOTA SUPER
BOWL XXVI, INC.

The first 5000 people who pre-register will receive a free Warm Up...Work Out T-shirt. . . . In addition, participants will get a certificate from the President's Council on Physical Fitness. . . .

Making the best of the long wait for an autograph, fans lean into position to snap a photo of quarterback Warren Moon.

The Celebrity Autograph Party was just one of the "hot" events organized for the home crowd's preview of the Party Under Glass. Retired football stars and players from teams that didn't make it to the Super Bowl were stationed throughout the skyways. Like pilgrims, faithful fans queued up and patiently awaited their brief moment of conversation. They brought pictures, football cards, shirts, and footballs for their heroes to sign. The lines stretched through the retail corridors and at the end of the afternoon disappointment supplanted the excitement of anticipation. At 4 p.m. the party ended and the celebrity athletes won their release from the bonds of public adoration.

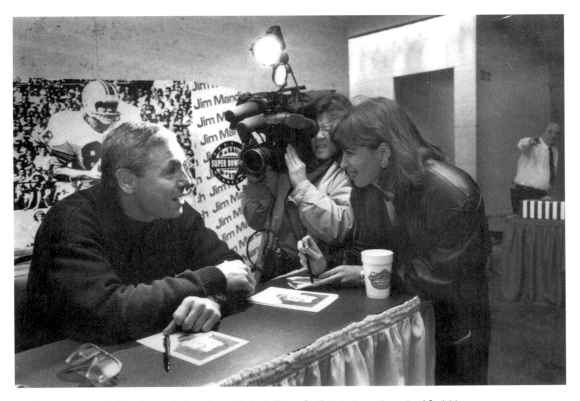

Local news crews combed the skyways for interviews with football stars for their stories on Super Bowl festivities.

News Release

MINNESOTA SUPER BOWL XXVI, INC.

Football fans are invited to get autographs from some of their favorite players. At least eight current and former football players, including Otis Anderson of the New York Giants, Jerome Brown of the Philadelphia Eagles, Pat Swilling of the New Orleans Saints and Warren Moon of the Houston Oilers, will be stationed in various Skyway atriums signing free autographs. Other stars are expected, including Shari Lewis, who will be pleased to sign the special Minnesota Super Bowl Miss Lamb Chop being sold at Target Stores to benefit Success by 6.

More than forty NFL players conducted two football clinics for fifteen hundred preselected children.

Michael Hegsrand and Joseph Laurainitis started their business in the back room of a gym in a Minneapolis suburb. They began making Zubaz, loose-fitting pants that became popular among "turkey-thighed" weight lifters. Zubaz took off and their company expanded; Warrior Distributing Corporation signed licensing agreements with the NFL, major league baseball, and about one hundred college teams. But the fad peaked, and hoping to prevent the company's demise, Zubaz diversified, making T-shirts, hats, sweatshirts, denims, and accessories. Cognizant of the promotional vehicle in their midst, Zubaz clothed football-clinic participants in free pants and T-shirts. Zubaz Super Bowl-themed merchandise was available all over town, with sales expected to reach 10,000 to 12,000 items.

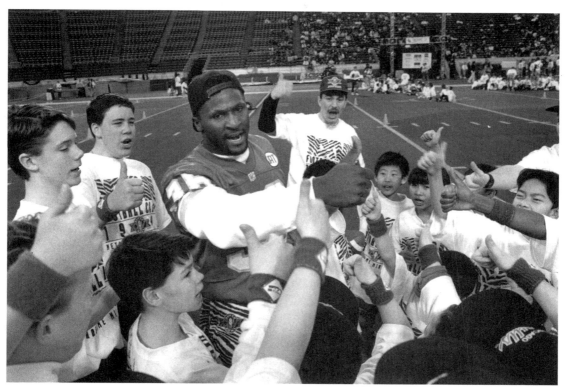

Drills end with a huddle and thumbs-up.

News Release

MINNESOTA SUPER
BOWL XXVI, INC.

The weekend will provide the most public access to the largest number of current and former NFL players. In all, more than 80 current and former NFL players will participate in weekend events.

"This really is a great opportunity for Minnesotans to experience the thrill of the Super Bowl coming to the Twin Cities," Nelson said. "We can showcase and enjoy together all the things we love about living here."

Commerce

Stories of all kinds spring from the Super Bowl. The media tell most of the tales people see and hear. Every year sports reporters converge en masse on the Super Bowl host city to cover the game. A reporter from the *Rocky Mountain News* provided an idealized description of the Super Bowl sportswriter's task for readers of his newspaper: "It's 7 a.m. It's 67 degrees. Palm trees are shaking outside my window, a Pacific breeze coming in through the open patio door. I spend the morning doing my job, which, at these Super Bowls, consists of turning monosyllabic grunts into sports poetry, then spending the afternoon spraying golfballs along the greensward of some local public links."[1]

Network TV sports departments and TV sports networks spin tales from the raw material provided on the field of play, in the locker room, and at the continual stream of press conferences held during Super Bowl week. Editors and producers entrust only the most accomplished analysts of the game with the important task of sports reporting. Former star players and successful coaches work alongside experienced media personnel to fill the ranks of broadcast announcers, further cementing ties between the media and the NFL. Commentators call the game and inject it with drama, promoting the industries that reward them with star status. Sports announcers address an enormous international audience. According to NFL figures, more than 120 million people in the U.S. alone watched the 1992 television broadcast of Super Bowl XXVI. In total, the league claims 750 million Super Bowl viewers in sixty countries.[2]

Other less visible narrators participate in creating Super Bowl stories. Perpetuating its own interests, the NFL labors to project a positive image of the sport and the activities of the league. Broadcast networks share the league's interests because of the alliance forged between television and pro football. The league provides the networks with football games to use as TV programming; the networks provide the league with a vehicle for the

mass distribution of its wares: professional football, licensed products, and special events. The networks sell football fans to corporate advertisers, and corporations sponsor activities of the NFL to help sustain the mutually beneficial cycle of exchange. Together these interlocked multimillion-dollar industries tell their version of the Super Bowl story.

Sports journalism pitches in by providing free promotion in the guise of information. Sports reporting could be subsumed by business and financial news; nevertheless, sport has been privileged with its own niche in print and on the air. In daily newspapers and local news broadcasts sport narratives share space with stories regarded as newsworthy and important to the conduct of everyday life. The special status conferred by the media upon sport validates its status as a significant cultural form and forum. Compared to professional sports, endeavors like science or art occupy a marginal position in the hierarchy reified by U.S. news media. But reporters' sports narratives relate more than news about a lucrative industry.

As tales told predominantly by men, about men, to men, sports reporting encodes messages about masculinity, and, cast oppositionally, femininity. Scores and statistics narrate the accomplishments of exceptional athletes who provide a model against which readers can judge their own merits. Except for the few sports exclusive to female athletes, the standard is set by men. Rather than having women compete in a male-dominated arena, football broadcasts suggest that women should perform in a league of their own— the cheerleading squad. In this alternative competitive arena women vie only with one another; they are not bested by men. Just as all-American boys are trained in childhood to become future ballplayers and sports aficionados, most girls prepare to perform in support roles and compete only on the sidelines. On the football field players' performances become the stuff of sports sagas, their movements consumed by the camera lens. Women perform too, but their efforts go unchronicled, despite the camera's persistent caress.

Viewed in historical perspective, the emergence of sport as an exclusively male domain can be related to the growth of industrialization and bureaucratization during the nineteenth century. Changing patterns of work wrested patriarchal authority from the male householder and began altering relationships among men and women. As men and women became wageearners, corporate managers assumed control of their labor and its products, eroding traditional male authority within the domestic arena. Worries surfaced that masculinity would surrender to effeminacy, and organizations devoted to the preservation and inculcation of manly ideals sprang up—the Boy Scouts, the YMCA, athletic clubs. Sport provided a proving ground for masculinity, an opportunity disassociated from the workday routines of industrial production. Although women now actively engage in competitive sport, the near invisibility of women's athletics suggests that the will to maintain sport as a bastion of masculinity persists.

What do spectators draw from epic narratives of football past and present? The meaning its fans derive from football can only be surmised: the functions and gratifications of spectatorship for so vast an audience can hardly be captured in neat generalities. Viewers make their repeated return to the stadium for complexly textured reasons, and systematic study intimidates even the hardiest audience researchers. One intrepid sociologist, Janet Lever, set out to understand the meaning of Brazilian football (soccer) for its fans and

concluded that "fandom" strengthens social bonds, cutting across divisions of race and class—but not gender. She suggests that American football serves a similar integrational function, but the nature of differing groups' interactions with NFL football hasn't yet been clearly delineated.[3]

Representatives of the NFL and the press offer their own commonsense notions regarding the popularity of football. Paul Tagliabue, NFL commissioner, delivered this message to "shareholders" very much in the manner of the chairman of the board:

> Today, the National Football League is consistently recognized in fan surveys as America's favorite sports league. The NFL has become a powerful force in the American lifestyle, and it is gaining increasing strength every year as a worldwide attraction.
>
> This stature has been attained in large measure by the NFL's long-standing commitment to the highest standards, standards that demand rugged competition on the field and quality service to fans in stadiums, on television, and in our communities.
>
> Last year, we enjoyed another outstanding season by any measure.
>
> The action on the field was highly competitive once again, highlighted by great team and individual performances. Half of our 224 regular-season games were decided by a touchdown or less, the second highest number in the past 22 years. Eighteen teams remained in contention for Super Bowl XXVI entering the final two weeks of the season. The skill of the athletes and the drama of the season produced record attendance for the third year in a row, nearly 62,000 per game. Our television audience also remained strong.[4]

During Super Bowl week the NFL mounted a theme park at the Minneapolis convention center, "The NFL Experience," an event replete with opportunities for idolatry. Fans were invited to step into the shoes of their heroes: to run like Darrell Greene or throw like Dan Marino. One exhibit allowed visitors to measure their own physical attributes in comparison with star players. Fans could visit a "real locker room" and a "real CBS broadcast booth," and witness the "fascinating" process used to make a regulation football. The exhibits erected at "The NFL Experience" give some insight into the NFL's conception of fans' "experience" of football and the pleasures fans derive from spectatorship. Visitors confronted big men, strong and powerful, men who set the standard. Corporate icons represented other big, strong, powerful men: captains of industry, commanding the thirty-two corporations sponsoring exhibits. In solidarity, these giants drove home another message affirming the strength, virility, and naturalness of the economic order perpetuating "The NFL Experience".

The NFL has developed its own strategies to help others tell its story. Each year the NFL publishes a volume that looks and reads like an annual report—*The NFL and You*. In words and pictures its vibrant color pages define the "NFL Experience," and provide brief profiles of the Super Bowl, NFL history, the league's teams, and the organization of the league itself. The volume concludes by outlining the league's good deeds, among them its charitable activities, educational efforts, and counseling programs. Among this list of

public works an entry on "NFL International" lauds NFL efforts to "globalize." It frames economic and cultural colonization as diplomacy: "The popularity of the NFL in the United States gives us the opportunity to be an ambassador of our sports culture to nations throughout the world. And the interest and enthusiasm for our game expressed by people everywhere provides us with greater incentive towards globalization of the NFL."[5] *The NFL and You* offers readers an authoritative text that delivers advertisement in the trappings of information, a corporate report on the state of the pro football enterprise.

Facilitating the flow of information during Super Bowl week, the NFL held daily press conferences. The league and the media both made their headquarters at the Hyatt Regency, centralizing the activities of these partners. A sample from the "Super Bowl XXVI Media Information Events & Time Schedule" suggests the effort put forth by the NFL to expedite media access to story material. Tuesday: sessions with AFC and NFC champions at the Metrodome. Wednesday and Thursday: buses depart Hyatt Regency for sessions with coaches and players at team hotels. Thursday afternoon: news conference on the World League and NFL International; NFL Players Association news conference. Friday: news conferences with head coaches, league commissioner. As the game approached, the press conferences grew increasingly frivolous: "Chuck Noll Press Conference—Noll, who coached four Super Bowl champions for the Pittsburgh Steelers, will toss the coin at Super Bowl XXVI."

Through press conferences and interview sessions the NFL provides conduit between players and the media. In order to fashion professional spokespersons from the stuff of athletes the NFL publishes a primer that teaches players how to become media savvy while outlining their contractual obligations to do so. The *NFL Media Relations Playbook* opens with this admonition:

> Cooperating with the news media is part of your job, just like practice, meetings, and standing at attention for the National Anthem. The NFL's popularity and the resulting revenues that produce your salary are tied directly to the exposure the NFL receives through the media. The story of the NFL and its players is told to the fans on a daily basis throughout the year by thousands of newspapers, magazines, radio stations, television networks, and television stations. This publicity is the envy of other businesses, which spend millions of dollars on advertising to generate a fraction of the exposure received by the NFL. Don't underestimate the fact that NFL players average nearly $400,000 per year in salary. You should view your obligation to cooperate with the media as an opportunity to promote yourself as well as your team and sport.[6]

The *Playbook* asserts its rules of conduct by invoking the mutual benefits yielded by cooperation. Those who exploit media attention and "develop a positive image in the community" may open up "long-term business and career opportunities" in such fields as broadcasting. The *Playbook* entices by alluding to the successful post-NFL careers of Irv Cross and Dan Dierdorf, but it fails to inform players that these success stories are exceptional cases, not commonplace occurrences. After NFL careers, most of the athletes without permanent physical disabilities move into occupations commensurate with their educational level.[7] Having made its case, the *Playbook* proceeds with strategies for conducting a good interview, including tips on "body language" and "traps to avoid."

Preparation: "Be sure you know about your team and yourself. These are the two main topics of interviews with NFL players. Get to know your teammates and the history of your team. Read your club's media guide, which includes biographies of current players and a team history. Be prepared to discuss your background. If you earned your college degree, don't hesitate to mention that fact. What are your likes and dislikes? Do you have any famous relatives? Be colorful. Be likable. Show personality." Deliver YOUR message: "Your goal with the media should be to put yourself in the best possible light with the real audience—the fans. You can do this by always delivering a positive message, no matter the circumstances."

Players who abide by the codes set forth in the *NFL Media Relations Playbook* work with the media to narrate the NFL story. Players who contest the media relations policy suffer the consequences. Although their goals may appear to diverge—good reporters seek controversy, good players mask it—both know that their livelihoods depend on the success of their convergent industries. Players provide the quotes from which reporters craft stories, and the media conglomerates that control newspapers, magazines and television networks disseminate the word. Despite the involvement of many actors in the narration process, the NFL provides the script. With a multimillion-dollar enterprise at stake, the league's story is far too important to be told by anyone else.

THE MINNESOTA STORY

While the NFL told its story, the Minnesota Super Bowl XXVI Task Force busied itself with its own narrative event. The arrival of the press set in motion a set of strategies designed to fully exploit the Twin Cities' monopoly on the media. The function of the Minnesota Story had been clearly stated by Marilyn Carlson Nelson. In addition to the immediate economic advantage accruing to a finite group of local companies, especially those in the "hospitality industry," the potential for long-term earnings loomed: "Hundreds of corporate convention and meeting planners will be in town for Super Bowl festivities—many for the first time—and we want them to discover the many pleasures of Minnesota, ranging from the warmth of the people to the diversity of leisure pursuits and the abundance of cultural opportunities. If they like what they see, not only will they be back, but in all likelihood they'll bring with them business and trade association conventions and corporate meetings, which can generate revenue for our state for decades to come."

The public relations firms ensconced on the task force elaborated a full-blown campaign designed to impress visitors with the Twin Cities and its inhabitants. They focused their pitch on the media, the most effective vehicle for disseminating the message. Task force planning documents envisioned this role for the media: "Will tell our story to the world; primary goal is to provide them with the information and direction to write that story and, secondarily, to make their jobs easier and their stay an enjoyable one." An arsenal of strategies for shaping their stories awaited reporters who deplaned at Twin Cities International Airport, ranging from expansive displays of helpfulness to conveniently pre-packaged story ideas. "Ambassadors" combed the airport looking for reporters; once the reporters were found, the ambassadors led them to the media hospitality lounge, refreshed them with coffee and donuts, supplied them with packets of information about the Twin Cities, and finally, after exhausting the welcome routine, dispatched them to their hotels.

Super Bowl XXVI · Minnesota Media Kit

Story Ideas

Minnesota–Hot Spot for Big League Sports

The Twin Cities comprise the smallest market in the U.S. with four major professional sports teams plus a Big Ten sports school—the Minnesota Vikings football team, the champion Minnesota Twins baseball team, the National Hockey League's North Stars, the Minnesota Timberwolves basketball team plus the University of Minnesota Gophers.

Hailed by USA TODAY as an emerging mecca for big league sports competitions, the Twin Cities of Minneapolis and St. Paul will have hosted several major events in just two years by the end of 1992, including:

- NCAA Final Four, April '92
- Super Bowl XXVI, January '92
- International Special Olympics, July '91
- PGA U.S. Open, June '91
- Stanley Cup Playoffs, April-May '91
- NCAA Regional Playoffs, March '91
- NCAA Hockey Final Four, March '91
- WCHA Hockey, March '92
- Women's Final Four, April '92

How do the Twin Cities, with a population of less than two million people, support all of this activity? Are Minnesota fans really as genteel as they are reputed to be?

Contact: Dave Mona
 Mona Meyer McGrath & Gavin
 (612)831-8515

No Place for Couch Potatoes

With 12,034 lakes and more than 6,000 miles of rivers and streams, Minnesota boasts more shoreline than California, Florida and Hawaii combined! And Minnesotans love nature and the out of doors, regardless of the time of year. The sate has more than 12,000 miles of snowmobile trails— more than any other state—the largest population of timberwolves in the lower 48 states, the largest population of nesting bald eagles of any state except Alaska, more golfers per capita than any other state and more registered water craft per capita than any other state. Fishing is perhaps the number one outdoor pastime in this state of four million people, where more than 2.3 million will go fishing this year.

Contact: Steve Markuson
 Director of Advertising & Public Relations
 Minnesota Office of Tourism
 1-800-657-3638

Upon check-in at the NFL Media Center at the Hyatt Regency, reporters received complimentary media bags from the NFL with the Minnesota Media Kit tucked inside. The weighty compendium provided reporters with all they needed to write the Minnesota story. There were press releases on each scheduled event and helpful "backgrounders" on the state, its weather, and Minnesota sports. Longer, more detailed news releases profiled the attractive qualities of Minnesota life, the area companies providing high-tech communications for the Super Bowl, and the generous support provided by local corporations. The media kit included a four-page document, "Story Ideas." The story suggestions appeared with their lead paragraphs already written by public relations firms. The name and telephone number of a contact person offering follow-up information completed the package.

Helpfulness continued unabated. The task force faxed daily "media advisories" to the NFL Media Center providing an up-to-the-minute list of breaking story ideas and photo opportunities. The task force set up its own "Media Service and Information Center," staffed by "local p. r. volunteers" prepared to "assist with story ideas, area history, events schedules and information." Librarians from the Minneapolis Public Library staffed a "media hotline" to help reporters access information "on practically anything, including sports history, local lore and national statistics." Printers, faxes and copying services were available at the center to facilitate reporters' work. When reporters needed equipment the task force offered loans, from laptops to tape recorders. And if in the course of writing the Minnesota story a reporter developed a headache, the task force center dispensed aspirin, washed down, no doubt, with soothing expressions of sympathy.

The task force came up with specific strategies to augment the work of broadcast journalists. They produced a video news release "highlighting the strengths of the Twin Cities metro area" and mailed 240 copies to television news departments in NFL cities, cable outlets like ESPN and Black Entertainment Television, and European television stations. The PR committee contrived a "buddy system," pairing out-of-town reporters with "media savvy volunteers who can serve as a resource to the Twin Cities." Prior to Super Bowl week, forty of these "go-fers" contacted network-affiliated television producers in NFL markets, offering their services as liaisons available to "assist news crews with learning about and getting around in the Twin Cities area." The task force encouraged media go-fers to use the "Recommended Stand-up and Live Shot Locations" developed for television reporters. The list with its dotted map marking prime locations had been mailed in advance to local affiliates in all NFL team cities and were distributed at the NFL Media Center.

The task force had anticipated reporters' professional needs and supplied them with story material and expert assistance. Consistent with their thorough planning, the task force also anticipated the entertainment needs of their chroniclers. Well aware that they couldn't offer beaches, golf courses, or 72-degree temperatures like most Super Bowl cities, Minnesota's Super Hosts scheduled a variety of events designed to mitigate discontent and unfavorable prose. Parties for the press offered a variety of temptations: reporters could visit the still-under-construction behemoth, the Mall of America, eat at the food court, and attend a professional hockey game, with a dessert buffet finale; at the party sponsored by Jostens reporters could feast and then adhere themselves to a wall of velcro; a day-long event offered outdoor "wintertainment"—snowmobiling, cross-country

skiing, and ice fishing. St. Paul Companies hosted a special reception for international media. To fend off post-party paunch the task force engaged two health-and-fitness clubs for reporters' use.

Like the NFL, the task force attempted to build an alliance with the media and position itself to play an instrumental role in crafting a beneficial story. Despite the years of effort focused on fully exploiting the promotional opportunities the Super Bowl provides, a piece of the puzzle still eluded the Minnesota task force: mutual interest. Out-of-town reporters professed no special interest in the Twin Cities. The economic prosperity of the region caused them little immediate concern. And though they might tolerate an occasional northern Super Bowl, reporters considered hot temperatures, not "hot hosts," an integral feature of covering football's annual celebration. Unlike the NFL, the task force had to hard-sell its product to the media, to pique the interest of the press so that reporters would see more than a luxury hotel and a domed stadium. The task force, peopled with experts in promotion, marketing, and finance, embraced the challenge and produced an unparalleled campaign to win the hearts, minds, and pens of the visiting press. As Super Bowl week progressed, they collected articles from newspapers around the country, hoping to find evidence of their success.

In addition to wooing the media, the task force worked to impress out-of-town visitors with the excitement and sophistication of the Twin Cities. Even though ticket holders couldn't broadcast the Minnesota story, they could provide favorable word-of-mouth advertising. Super Bowl ticket holders presented an attractive target audience for the sales pitch: 80 percent are males, 53 percent earn an annual income over $50,000, 27 percent own their companies, and 25 percent are officers of their companies. The task force hoped visitors would enjoy themselves, spend as much money as possible, and return with future convention business. It was difficult for the task force to devise specific strategies to facilitate ticket holders' pleasure because no single route provided access to them. The task force managed to reach some visitors by providing information and ideas to the travel planners organizing their trips, but many others escaped the influence of these tactics. Whether or not the task force directly influenced travelers' itineraries, they would have an incoming audience to address. Prior to visitors' arrival the task force endeavored to groom locals to be gracious hosts. By involving a squadron of volunteers, and organizing football festivities for the home crowd prior to Super Bowl week, the task force attempted to transform locals into an enthusiastic pep squad, cheering on the corporate class.

A DIFFERENT TALE The NFL and the Minnesota Super Bowl XXVI Task Force spent years constructing the apparatus that would enable their narrators to craft the right story. Lacking their foresight, I didn't plan my campaign in advance. My spontaneous endeavor to examine the Super Bowl fell into place haphazardly and evolved into a group effort sustained not by the promise of profit but by intellectual curiosity. Our story would not result from generous gifts, organizational expertise, or massive labor power. Although we knew when and where our work would begin, we had no idea precisely where it (or we) would end. Ours was a journey of discovery; we had no elaborate script directing our efforts. We knew that a story had been molded, requiring only a gentle massage and a reporter's imprimatur to get it into shape. By following the trail left for the press—the relentless stream of press conferences and corporate-

sponsored special events, the neatly mapped live-shot locations and photo-opportunities—we could efficiently produce a professional-caliber story and still have time for parties and free food and drink. Confronting temptation, we resolved that the seductions awaiting other storytellers would not bend us to the same purpose.

Although we didn't make use of the task force media kit, we did have story ideas to investigate. Knowing we were entering an exclusively male domain we hoped to examine the conceptions of gender linked to the Super Bowl, on and off the field. Enveloped in hyperbole, the Super Bowl magnifies attributes of masculinity and provides an arena in which machismo is the norm. Conceptions of femininity undergo the same metamorphosis, and women, enhanced to fit the physical stereotypes that football invokes, cheer for the team from the sidelines or sell beer to spectators during commercial breaks from the action on the field. We wanted to find out whether these gender norms extended beyond the stadium to the terrain occupied by Super Bowl spectators. Would we find macho men displaying their glamorous women in Twin Cities bars and restaurants? What uniforms would men and women wear off the playing field?

For weeks preceding the game, stories in the local media heralded the imminent excitement and opportunity the Super Bowl would provide. Many news anchors and reporters uncritically promoted the benefits of the Super Bowl and the relentlessly upbeat coverage solicited support from the local community. The Super Bowl was a star-studded party and we were privileged to be its hosts. We were implicitly encouraged to let loose the full force of our "Minnesota-nice." This barrage of messages generated another story idea. We proposed to find out what was involved in hosting a party of this magnitude. In what roles were we locals to be cast? We wanted to learn more about our guests. Whose enjoyment were we being asked to facilitate? We were told many VIPs would be coming to town. What kinds of people filled those very important shoes? That the Super Bowl was a celebration seemed taken for granted by most commentators, but what exactly were we celebrating?

We witnessed workers throughout Minneapolis transforming the appearance of the city, preparing for the party. They hung banners, cleaned the streets, and vacuumed the skyways. Corporations helped with the decorating too. Giant inflatable soda and beer cans grew out of rooftops near the Metrodome. Law enforcement aggressively relocated the inebriated and the homeless, and removed traces of the casualties of the economic order that made the moment of celebration possible. What would happen to us when our visitors arrived? Would life go on as usual beyond the perimeter of downtown Minneapolis? How soon would we notice the benefits of hosting the Super Bowl?

The Super Bowl XXVI Task Force and the NFL inspired many of the story ideas we generated. But some of the conceptions in our playbook would not have occurred to the opposing team. Even though we drew inspiration from them, we planned to depart from the text authored by the public relations team corporate elites had fielded. Out-staffed, under-organized, and unfunded, we knew we competed on an uneven playing field. Nevertheless, as game time approached, we entered the arena, an enthusiastic group of documentarists resolved to vie with the dominant narrative about to command the field.

NOTES

[1] Bob Kravitz, "There's so much to do it's boring." Rocky Mountain News, Denver, Colorado, Jan. 24, 1992.

[2] *The NFL and You, 1992-1993.*, NFL, 1992, p. 13; 17.

[3] Janet Lever, *Soccer Madness*, University of Chicago Press, 1983.

[4] Paul Tagliabue, *The NFL and You, 1992-1993.*, NFL, 1992, p. 2-3.

[5] Ibid., p. 103.

[6] *NFL Media Relations Playbook*, NFL, 1991, p.2.

[7] George H. Sage, *Power and Ideology in American Sport*, p.159. Human Kinetics Books, 1990.

Like the opening kickoff, the arrival of the Buffalo Bills and the Washington Redskins signals the start of Super Bowl festivities. Buffalo Bills quarterback Jim Kelly greets the press, corraled and shivering atop flatbed trucks brought in to improve sightlines.

Name: Thomas Jardine
Occupation: Vice president Public Relations/Public Affairs, Carlson Companies Inc.
Task force assignment: Chair, Minneapolis-St. Paul Airport Hospitality. "I'm in charge of meeting, greeting, informing and helping Super Bowl guests and the news media as they arrive at the airport."
In your opinion, what will be the most exciting aspect of Super Bowl week?: "It could happen right at the airport as 1,000 volunteers shower welcome to all our guests while good looking men and women dressed in tuxedos play white baby grand pianos. Visitors may never leave the airport for the Super Bowl."

MINNESOTA SUPER BOWL XXVI TASK FORCE PLAYBOOK

Name: Sue Hodder
Occupation: Maker of videos on baking and children's gardening.
Task force assignment: Chair, Amenities Committee; Public Relations Committee member.
What has been the most rewarding part of your Super Bowl Task Force experience?: "Meeting and working with new people. The enthusiasm connected with this is fantastic. Lots of creative thinking."
In your opinion, what will be the most exciting aspect of Super Bowl week?: "My job! Coordinating all of the 'Welcome' packages for the arriving visitors and getting them to the hotels on time, and getting the Minnesota spirit extended to each visitor."

Name: Paul Ridgeway
Occupation: President, Ridgeway Associates Special Events Co.
Task force assignment: Executive Committee; chair, Transportation, Logistics and Security Committee.
What has been your funniest task force experience?: "Making people believe that I don't have game tickets and that I am unable to predict the game day weather."
What advice would you give to future Super Bowl host cities?: "It's bigger than you can imagine. Assume that you are planning for an event that is only exceeded in size by World War II or the Second Coming."

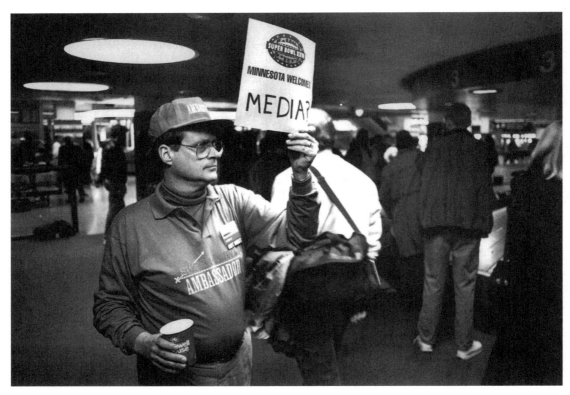

One of many volunteer Super Bowl ambassadors seeks an opportunity to offer a warm welcome to members of the press corps, anticipated to exceed three thousand.

From downtown Minneapolis to Twin Cities International Airport, the stage had been set for the arrival of Super Bowl visitors. Helium balloons imprinted with the Super Bowl XXVI logo decorated the airport, and grand pianos, provided by a local chain of music stores, were strategically placed so that tuxedo-clad musicians could entertain arrivals. From the moment they disembarked visitors were assailed by the task force message: Minnesotans are hot hosts! Reporters were first on the scene, arriving in time for Tuesday's media day at the Metrodome. Anticipating their arrival, the task force unleashed its ambassadors to meet and greet the press. Financed by the Dayton Hudson Department Store Company, smiling ambassadors, easily identifiable in their blue shirts, red caps, and "hot host" buttons, combed the terminal searching for reporters. To facilitate the task, they scanned lists of arriving journalists complete with their incoming flight numbers. Scattered throughout the airport, the ambassadors stood, patiently awaiting the opportunity to offer a warm welcome. Ambassadors escorted reporters to the News Media Hospitality/VIP Center which was stocked with coffee, donuts, newspapers, information, and souvenirs. Demonstrating helpfulness, ambassadors confirmed reporters' ground transport and dispatched them well primed to tell the Minnesota story.

Tuesday, 5:00 p.m.: accredited media are given one hour to shoot the site of Super Bowl XXVI. No one is permitted on the field.

There's so much to do it's boring

They call themselves Super Hosts. It says so right on their buttons, which are only slightly smaller than Joe Jacoby. They are hopelessly chipper souls whose only goal is to make you, Our Visitor, have the time of your life.

Whether you like it or not.

"Good morning!!" screamed a Super Host as I boarded the media bus in the cloak of morning darkness. "Grblechmgmgrrgle," I replied. "Where's the coffee?"

"It's 16 degrees!!" she said, just loud enough so the folks in Wisconsin could hear. "Now you have a wonderful and successful day!!!"...

The problem, basically, is that these Super Hosts . . . are so concerned about the weather they have gone completely berserk providing visitors with things to do. They know we can't golf or sit by the pool, so they've taken it upon their hospitable selves to entertain

ROCKY MOUNTAIN NEWS
DENVER, COLORADO

us every single minute night and day.

News conferences. Soirees. Ice-fishing expeditions.

I'm sitting here in the press room, and the announcement comes in: "Gene Upshaw of the NFLPA is currently available for interviews. At 1 p.m., Bills owner Ralph Wilson will hold a news conference. At 2 p.m., new Packers coach Mike Holmgren will be available. At 4 p.m. buses leave for the media party at . . ."

Oh, and what about this little flier I found under my door this morning? "Media Advisory. Montana, Kelly Nupe It And Talk Super Bowl In Unique News Conference. . . .The two superstars will both be available to discuss the Super Bowl and how they 'Nupe It' with Nuprin". "Uh, excuse me Joe, but do you prefer gel caps or the tablets?"

Yes I am having a wonderful and successful week. Wish you were here.

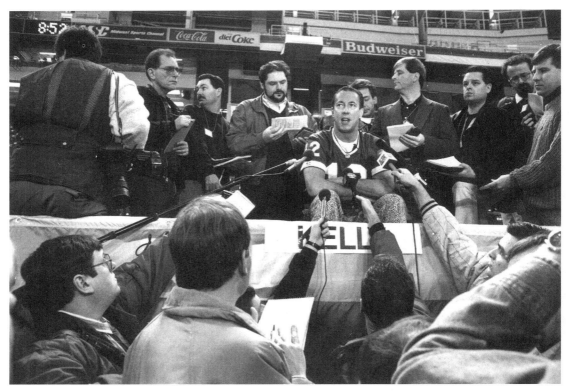

Buffalo Bills quarterback Jim Kelly delivers the raw material from which sports news will be made.

Media Day at the Metrodome had arrived. The press got its first chance to interview and photograph the championship teams; we got a chance to observe the press corps in action. By 8:15 a.m. buses from the Hyatt Regency unloaded their cargo and reporters surged into the stadium.The Bills appeared from 8:30 to 9:30 a.m., followed by the Redskins from 10:30 to 11:30. Security teams kept everyone off the field as the grounds crew groomed the artificial turf for the game. The most important players and the coaches were given their own designated positions in the stands. Some sat, some stood behind a podium delivering their answers to the reporters crowded around them. Reporters who failed to elbow their way to a good vantage point had to settle for next best, holding their notebooks and microphones close to a speaker that broadcast the interview taking place in the seats above. Like the others, I was drawn to these important players, so when the press made its move to surround an interviewee I dove into the crowd and their momentum carried me in for the shot. I photographed players immersed in reporters whose jobs compelled them to make news from the practiced responses they heard. After an interview ended the pack moved on and I rode the wave again. At the end of the first hour the Bills exited and so did I, heading for the expected refreshments. Long tables awaited, piled high with food and drink to replenish our energy for the second half.

Surplus reporters are offered a loudspeaker from which to hear the interview proceeding in the stands above. Surplus players who drew little attention from the press lounged, unoccupied, while their illustrious teammates held court.

Body Language

Television interviews are a fact of life for all NFL players. A great deal of the impression you make in television interviews results from your personal style—your body language.

Your dress, your facial expressions, and your posture all convey messages to the television audience. What message do you want to send?

Picture a player wearing sunglasses and a torn T-shirt, chewing gum, not smiling, slouching, shifting from side to side, and never looking at the reporter asking the questions.

NFL MEDIA RELATIONS PLAYBOOK

Picture another player, smiling, standing up straight, looking the reporter in the eye, speaking clearly, and showing enthusiasm.

It doesn't take a genius to figure out which of these players has a better chance for endorsements and business opportunities.

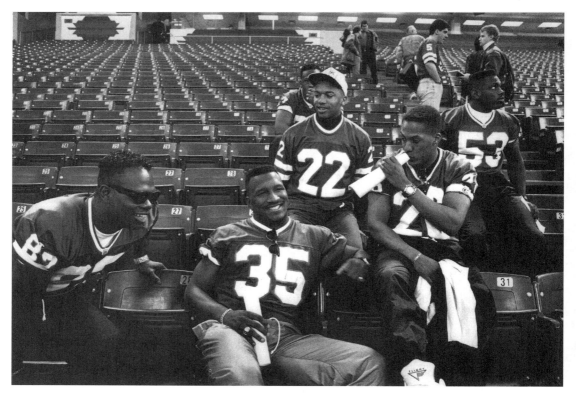

Away from the eager throng of reporters, rank-and-file Buffalo Bills players keep each other company while waiting for the media session to end.

Forgotten in the commotion, less newsworthy players sat together in groups and waited, just in case a reporter approached, in accordance with the media clause in their contracts. Getting close to these players presented no challenge, and there was no wave of reporters to ride. Reversing the usual protocol they hailed me and asked, "Why don't you take our picture?" Maybe they called out to me because, like theirs, my activities took place on the periphery. I approached and began photographing, and they kept on talking to each other, loudly enough for me to hear their humorous remarks. I had no quota of pictures to produce and no deadlines to meet so I lingered and talked, laughing and joking with them. I imagine they had memorized the media "do's and don'ts," but in my presence they failed to talk in sound bites and I was glad because I wouldn't have known how to answer. They seemed to show a sense of humor. They didn't whine or complain. They smiled and seemed enthusiastic. They certainly were doing a good job of being available and cooperative. And they spoke English, although considering the fact that they all were Americans, I hardly expected them to speak anything else. It's a shame though, that they did so much work memorizing the rules to prepare for my presence. With such a small coterie it hardly seems likely that they will have the opportunity to win friends and influence people.

NFL Media Relations Playbook
Do's & Don'ts

**Everyone likes a top 10 list.
Here's one of interview do's:**

1. BE PREPARED. Knowledge is power. The more you know about the media, the more comfortable and confident you will be.

2. BE POSITIVE. Nobody likes a complainer. Whine in private, not in public.

3. PRAISE YOUR TEAMMATES. Nobody becomes successful on his own. You can never go wrong by giving credit to others.

4. TALK IN SOUND BITES. Keep your answers short and simple. Don't over-answer. Tell the audience what they need to know, not everything you know on a subject.

5. SMILE. It goes a long way.

6. BE ENTHUSIASTIC. It's part of your job as an athlete. It makes you exciting.

7. BE PERSONABLE. Show a sense of humor. Be a people person. Everyone likes a good story.

8. BE AVAILABLE AND COOPERATIVE. It's part of your obligation as a professional. And it's in your best interest.

9. BE POLITE IN DIFFICULT SITUATIONS. You will win friends and influence people.

10. BRIDGE TO YOUR MESSAGE. Give the answer you want to give.

Here's another top ten list:

1. DON'T SAY "NO COMMENT." Figure out a positive way to answer the question. "No comment" means you're guilty as charged.

2. DON'T TALK ABOUT MONEY. Nothing turns off fans like athletes talking about money. People want to hear about the games and the players. Refer questions about your contract to the club or your agent.

3. DON'T BE NEGATIVE. The quickest way out of town is to become a negative influence on your team. Lots of NFL players have cut short their careers by saying the wrong things to the media.

4. DON'T HIDE. You can't make the media disappear. Take a positive approach. Learn how to deal with the media and reap the benefits.

5. DON'T LOSE YOUR COOL. The media will test you when adversity comes your way. It's part of their job. Remember the real audience is the fans. Don't let the media get under your skin. Never be hostile. If you refuse to lose your cool, you'll be a winner in the media game.

6. DON'T USE FILLERS. Well, you know, it just doesn't, uhm, like, sound real good, you know?

7. DON'T FORGET THE FISH BOWL. You're living in one as an NFL player. Any of your actions during a game may be on television. The media are part of your life every day. Your behavior and remarks in the locker room when the media are present could wind up in the newspaper. You are a public figure. You are always "on."

8. DON'T BE SARCASTIC. It may be funny with your friends, but sarcasm doesn't come across well in newspaper quotes or television interviews unless you're a professional comedian.

9. DON'T COP AN ATTITUDE. Nice guys may finish last on the field, but they are definitely winners off the field. Remember "Mean" Joe Greene? He became successful after his Hall of Fame NFL career because he was anything but mean off the field.

10. DON'T USE SLANG. Speak English. It's likely to be a requirement for your next job.

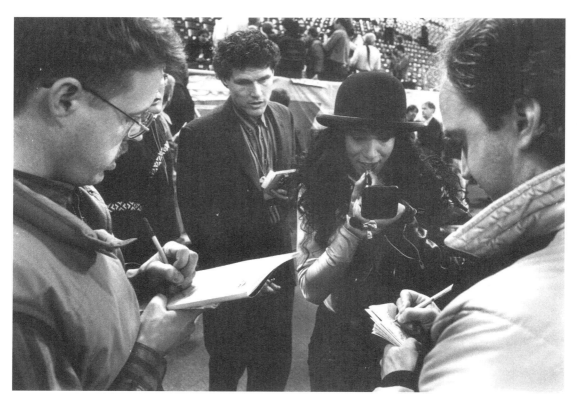

MTV host Downtown Julie Brown fields questions from fellow reporters while she freshens her lipstick between interviews.

A standout amid the assembled males, MTV video jockey Downtown Julie Brown worked the field, on special assignment for Inside Edition. *Unlike her male counterparts, she wore skintight black leather pants, a hot-pink silk top with cones that shaped her breasts like footballs, and a bowler hat. Her methods were distinctive. Rather than elbowing her way into position, she wriggled into place, the suddenly cooperative throng parting to allow her access. When she seated herself next to Redskins quarterback Mark Rypien she addressed him and her fellow reporters. "So, Mark Rypien, they tell me you've been sacked fewer times than other quarterbacks in the league . . . professionally, that is. What's your secret?" Downtown Julie Brown became the story on the field. Reporters followed her as she made her way around the Metrodome, interviewing her between the interviews she was taping. Everyone must have needed a break from the serious business of football.*

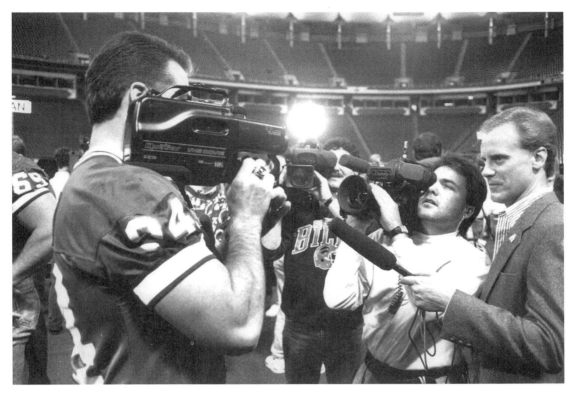

Players with camcorders documented their own Super Bowl experiences. Discovered by the press, this event became news, and reporters videotaped players videotaping reporters.

To NFL Players:

One of the unique aspects of life as an NFL player is the extraordinary amount of coverage our sport receives from the news media.

This media attention is important to the success of the NFL. It is the primary way we communicate to the fans who support our game. It is the reason cooperation with the news media is one of your professional obligations as specified in paragraph 4 of your contract and by NFL policy. And it means your conduct on and off the field will be under intense scrutiny because of your position as a public figure.

PAUL TAGLIABUE,
NFL MEDIA
RELATIONS PLAYBOOK

It sounds like a heavy burden—and in some ways it is—but there is no reason to fear the media. If you understand their role and prepare yourself properly, your relationship with the media can pay big dividends....

the courtship of
FUTILE ATTRACTIONS
Punch & Judy

HOT HOST

Local entertainers stationed throughout the skyways contributed to the carnival atmosphere that pervaded the usually somber downtown business district.

The final phase of the week's activities started with the arrival of Super Bowl ticket holders. The local community had been entertained and sent back home, making way first for the press and then for "our guests." The task force hoped that guests would stay as long as possible and spend as much money as possible. One task force member stated the group's position succinctly: "We welcome these people. We welcome their money." In anticipation of this new group of spenders the airport was "re-ballooned" and the grand pianos decked with red roses. High school bands, jugglers, and clowns were ready to entertain from the airport to the skyways in downtown Minneapolis. The time had come to prove that we were the "hot hosts" we claimed to be in the slogans on buttons, banners, and advertisements. Nearly sixty hours of free entertainment was scheduled for the stages erected in the Pillsbury Center and the IDS Center, the AFC and NFC "fan headquarters." The task force could simultaneously showcase the "Minneapolis Sound" and the city's commercial centers. The "players" for whom this show was planned had racked up their own impressive list of stats, numbers the task force repeatedly touted in its speeches and press releases: 80 percent of Super Bowl ticket holders are male, 53 percent earn over $50,000 annually, 27 percent own their own companies, and 25 percent are officers of their companies. I had trouble enough planning birthday parties for my boys, so it was hard to imagine coordinating so much entertainment. Fortunately the task force could rely on the expertise of Carlson Companies and other local corporate giants. The Super Bowl was just business as usual for the meeting, convention, and trade show planning division of the Carlson Marketing Group.

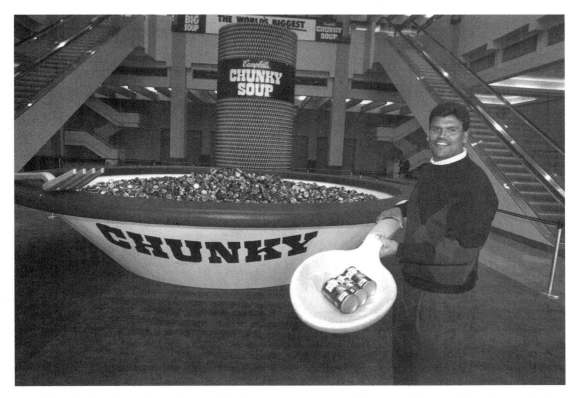

Campbell's cooked up all the right ingredients to yield a hearty promotional repast. The recipe included a celebrity spokesman mixed with a camera-worthy gimmick, and a giveaway—a free bowl of hot chicken noodle soup served in a commemorative mug.

Souper Bowl

If you want to stage a media event, it has to be really big, right? Campbell's certainly understands the concept: They will be unveiling the world's biggest (you may groan whenever you like) bowl of soup for the Super Bowl at 10:30 a.m. in the Plaza 2 lobby of the Minneapolis Convention Center, 1301 2nd Av. S. The bowl will be 20 feet across and will contain about 600 gallons of Campbell's new Chunky Classic Chicken Noodle Soup. All-pro lineman Anthony Muñoz, quite a large fellow himself, will help dish out a few servings with a giant fork and spoon, but most of the contents of the bowl will be presented to Second Harvest Food Bank.

MINNEAPOLIS
STAR TRIBUNE

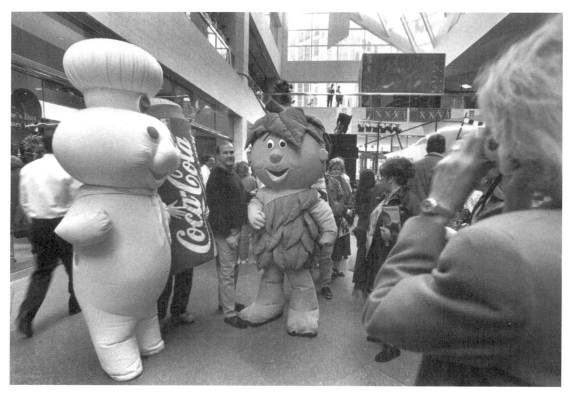

Pillsbury Center provided a forum for the Doughboy, the Little Green Sprout, and animated Coke and Diet Coke cans.

What might have seemed strange, people dressed as corporate symbols strolling the atria of downtown office towers, looked perfectly natural during Super Bowl week. The oversized Coke cans, the Doughboy, and the Little Green Sprout provided us with ideal picture elements to represent this grandiose celebration of commerce and commodification. I followed the friendly icons as they greeted passersby and I waited to photograph people's reactions as they materialized within the viewfinder's rectangle. Rather than respond with surprise, many acknowledged the Doughboy and the Little Green Sprout as if they were old friends. The less anthropomorphic Coke cans displayed their gregariousness as well and shook hands with all those who approached. A steady stream of people posed with these familiar icons for a souvenir snapshot. The novelty of their appearance triggered a photographic response from visitors and photojournalists. It lured me as well. Despite our intention to observe and critique this display of corporate presence, the provocation to photograph nevertheless supported the interests of Pillsbury and Coca-Cola, Eastman Kodak, Fuji Photo Film, Canon Camera, and Sony Corporation, all corporate sponsors of the NFL.

Locked out of the Metrodome by Coca-Cola, Pepsi contributed $1 million to construct a record-setting 165-foot-tall ice palace at the St. Paul Winter Carnival. Pepsi erected a hospitality tent nearby, with a "museum" to display its own artifacts of culture.

In contrast to the Super Bowl's glitzy, hard-sell advertising image, many of the corporate hosts prefer to keep quiet about their guest lists and entertainment activities. Some cite security reasons, and others say they don't want to let the competition know what they're up to. But many are afraid that their customers who weren't invited might feel snubbed.

Coca-Cola was less than talkative about its plans for the 300 to 400 grocery retailers and fast food executives it is bringing to the game. The guest list will also include winners of local promotions put on by Coca-Cola bottlers, according to Bob Bertini of the soft drink company.

SAINT PAUL
PIONEER PRESS

Coca-Cola's archrival, Pepsi-Cola, won't talk at all about its plans for entertaining Super Bowl guests.

"They prefer to keep it on a private basis," said Bob Hood, president of Gateway Promotions of San Diego, Calif., which is handling Pepsi's entertainment. "They have competitors who are trying to do the same thing."

"The NFL Experience's" "Look Like a Pro" exhibit allowed fans to assume the persona of a football star and snap a "Kodak Moment."

When we heard about "The NFL Experience", a theme park sponsored by American Express, we launched a pilgrimage to the convention center to view the NFL's own narrative about the meaning of football past, present, and future. For the $12 admission "The NFL Experience" offered opportunities to pay tribute to the game and its heroes, and to buy souvenirs and memorabilia. As with all the other events we had witnessed, corporate sponsors made clear their interest in the sport. Kodak sponsored the "Look Like a Pro" photo displays that enticed visitors to step behind the life-size replicas of football stars and take a commemorative snapshot; Starter, the maker of team logo jackets, presented the NFL Locker Room, giving fans, "A unique behind-the-scenes look at an authentic NFL Locker Room." "The NFL Experience" encouraged visitors to enact their own football fantasies, tempered by the knowledge that real players run faster, kick farther, and throw a football more accurately. Nurturing the next generation, NFL Properties, the league's sports marketing division, featured "The Ultimate Kids Bedroom: A dream bedroom for young fans featuring every imaginable NFL product from sheets to rugs, from curtains to furniture." NFL players made daily appearances for the three-day run of the event. I left with a clearer understanding that, like other trade shows, "The NFL Experience" was about selling—the league and its licensed products, its corporate sponsors, and the patriarchal authority it celebrated.

Fans attending "The NFL Experience" are dwarfed by the larger-than-life images that pay tribute to a century of NFL football.

Best Sports Event — The NFL Experience
Only a fraction of the football fans in Minneapolis during Super Bowl Week last January actually got to go to the game. "The NFL Experience" was created to give everyone in town during the big event a taste of the fun and excitement of pro football.

Part museum, part "fun zone," the four day event consisted of 32 exhibits, attractions and games in a convention hall designed to look like a football field.

"Experience"-goers could see how Wilson NFL game balls are made, try kicking a field goal, test their passing accuracy, tour a real broadcast booth, sample food from around the NFL, and see NFL Films features and historic photos and artifacts of the game.

American Express Travel Related Services was the primary sponsor; 32 companies also supported the event. Riddel sponsored a

BRANDWEEK
EVENT MARKETING
AWARDS

"testing center" demonstration of the durability of NFL equipment; B. Dalton sponsored an NFL book shop; and Foot Locker sold team merchandise.

The Experience was intended to position the NFL as sport's premier league, and to promote and enhance the image of the league, its 28 member clubs and the sponsors and licensees involved in the promotion. . . .

A national PR campaign and local print, radio, TV and billboards promoted the event. Male 18-to-34-year-old sports fans and their families were the primary targets.

Ticketmaster sold 85,000 tickets. TV crews from around the U.S., in town for the game, gave the event national exposure as well.

The event was such a success at cutting through the other Super Bowl clutter that it will be repeated in 1993 at Super Bowl XXVII in Pasadena, Calif. In addition, the NFL took The Experience on the road to six NFL cities.

Hank Stram fans solicited a photograph of themselves with their hero. Stram served as head coach and vice president of the Kansas City Chiefs for fifteen years before joining the CBS Sports team. Stram was lead radio announcer for Super Bowl XXVI.

The CBS Radio party was in full swing by the time I arrived. Network employees and advertising clients actively pursued the business at hand: consuming vast amounts of food and drink at a Minneapolis bar rented for the invitation-only party. A pair of elderly men cruised the room, umbilically linked to the camera and dual flash units they jointly operated. They appeared to perform an official function, documenting the party and the enjoyment of the corporate host's guests. Flashes burst from different corners of the bar, and the presence of busy contract photographers made me feel like less of a standout among the party-goers. It had already been a long day of shooting parties and events, beginning at 11 a.m. It was twelve hours later and the adrenaline rush sustaining me was starting to subside. How many parties could there be? How many did I really need to show? I set my camera down on the bar and ordered a beer. A CBS Radio employee engaged me in friendly conversation, and eyeing my camera he asked for a favor. "Would you mind taking a picture of me and some of my friends with Hank Stram? He's my hero. I can pay you for it; how about $25?" He had his agenda, I had mine. Abandoning my drink I followed him to the appointed place, where he and his friends arranged themselves around the legendary broadcaster. Once my flash fired I declared myself off-duty and returned to my place at the bar.

Young sports fans display the autographs they have accumulated by stalking players in the lobbies of the NFC and AFC champion teams' hotels.

America's Game

Fans. They can be found everywhere. In stadiums and arenas; at theaters and auditoriums. In living rooms and board rooms; on beaches and mountain tops.

And, in the midst of a storm: the Desert Storm that focused worldwide attention on the Persian Gulf region in 1990-1991.

The popularity of the National Football League, and the devotion of its multitude of fans, was never more profoundly expressed than in a five-sentence message sent to the NFL last March by Sergeant First Class W.C. "Bill" Simmons, who was stationed in Saudi Arabia with the Eighth Engineering Battalion of the First Cavalry Division.

"I would like to thank the NFL for its support of the soldiers deployed here in Saudi Arabia. I have been in the service for 18 years and the NFL has always shown support. However, this time it was personal to me. I had to get up early or stay up late to hear an NFL game, but it was worth it. It really did help."

THE NFL AND YOU
1992–1993

Fans. Oh, do we have them! And the NFL appreciates each and every one of the millions who profess the interest and enthusiastic support that, in 73 years since the league's origin on the dirt fields of the Midwest, has lifted this exciting and dramatic game to its position as the number-one spectator sport in America. The National Football League salutes you, our fans!

An exhibit at "The NFL Experience" offered fans the opportunity to "measure up to the pros," comparing their own physical attributes with those of star players. Most fans were dwarfed, especially the women who ventured a comparison.

The Super Bowl is a "guy thing," conceived by men, played by men, discussed by men, revered by men, exploited by men. Our observations and our pictures supported this commonsense assertion. Rather than belabor the obvious, we wanted to explore the roles in which the Super Bowl cast women. An exhibit at "The NFL Experience" helped us focus our thoughts: "Measure Up to the Pros: An interactive attraction that enables fans to measure up against the surprising physical attributes of the NFL stars." Athletes' physical endowments help make them visible to the public. This same standard applies to women. Remarkable football players are big and powerful; remarkable women are glamorous. Men act, women appear. Those who fail to "measure up" remain invisible, ignored by the camera's eye. NFL teams use cheerleading squads to adorn stadium sidelines and provide cutaways for broadcasts. In a similar move, models represented Budweiser beer at the Bud Bowl, providing visual counterpoint to swarms of neck-tied company execs. Costumed in cheerleader outfits they toured the Hyatt Regency ballroom in groups of three, arranging themselves so that the letters emblazoned on their chests: "Bud," "wei," and "ser," could be read in their proper order. A photographer offered free Polaroids to fans who wanted to pose with the mute, smiling women. Unenhanced by cosmetic remakes, costuming, or choreography, "ordinary," underrepresented women perform the roles of wife, girlfriend, mother, and daughter, in a mundane world unimproved by Super Bowl fantasy.

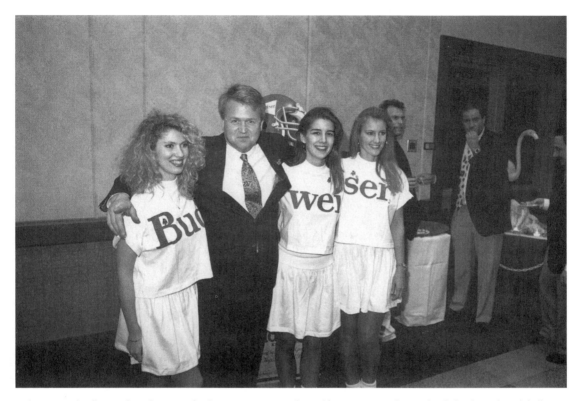

Anheuser-Busch sells more beer than any other brewing company in the world. Its promotional arsenal includes the Bud Bowl; bull terrier, Spuds MacKenzie; animated frogs; and cheerleading models.

Sports and Suds

Beer drinkers and sports fans are one and the same—indivisible, inseparable, identical! No one drinks more beer than a sports fan, and no one likes sports more than a beer drinker.

Statistical curves indicate that the age of maximum beer consumption and the age of maximum sports involvement are the same, both for men and for women. Peak beer-consuming years are 18 to 29, as are the peak sports-consuming years—for both participants and spectators. Among males 18 to 34, there is a core group of drinkers whose consumption is so phenomenal that even though they make up only 20% of the beer-drinking population, they consume an estimated 70% of all beer drunk in this country. Though the industry doesn't make a public point of it, these supersudsers are obviously an enormously important audience—and most easily reached with sports-associated salesmanship. As Miller's [Alan] Easton says, "Once you're into the demographics of sports, you are also into the total demographics of beer drinking. You get them all, from the couch potato spectator to the high-action, participating jocks—joggers, softball players, bowlers. Even at a very high price, it is an extremely cost-efficient buy. TV sports and beer commercials are a perfect marriage."

SPORTS ILLUSTRATED
AUGUST 1988

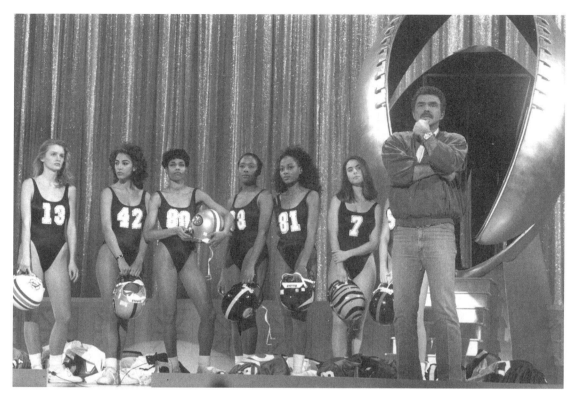

In rehearsal, Burt Reynolds's "dream team" awaits instructions on stage blocking.

It was another first, "Super Bowl Saturday Night." A press release informed that "the NFL—for the first time—will announce the winners of the game's top awards on this live TV show emanating from the Target Center in Minneapolis." The show was produced for the NFL by Radio City Music Hall Productions. Burt Reynolds hosted, with a cast of star entertainers: Tony Bennett, Huey Lewis & the News, Clint Black, Karyn White, Martin Mull, Boyz II Men and Another Bad Creation. Football heroes Joe Montana, Warren Moon, Gale Sayers, and Franco Harris presented the awards: NFL Man of the Year, NFL Rookie of the Year, NFL Lifetime Achievement Award, and NFL Coach of the Year. The press release promised an "exciting and memorable" finale. Jeffrey Osborne, accompanied by a fifty-player chorus including John Elway, Ronnie Lott, Jim Everett, Eric Dickerson and Michael Singletary, would perform a song composed for the event, "The Heart of a Hero." The song paid tribute to NFL players and their commitment to youth. The press kit said nothing about the opening of the show, exciting and memorable as it was. A giant football was lowered onto the stage, and from it emerged Burt Reynolds. He summoned his "dream team," a squad of ten women, costumed in helmets and football jerseys. They pranced onto the stage and ripped away their uniforms to reveal bathing suits, each with a sequined number stitched onto the front. Unlike other performers the "dream team" required no other identification. They functioned only as decorative objects dressing the stage for the production.

Taste of the NFL workers wore "perfect" uniforms which rendered them orderly, anonymous, and distinct from party attendees.

The event wasn't listed in the official Super Bowl week guide.

But few official events reflected Minnesota culture so well as a labor demonstration at the Hotel Normandy in downtown Minneapolis on Saturday. . . .By the time the demonstration was over at about 2 p.m., a handful of hotel guests had witnessed 17 people being politely arrested.

The pleasantness between those being arrested and those doing the arresting softened the somber struggle at the root of the demonstration.

In 1990, Tom Noble, who had sold the Normandy to Trammel Crow in 1985 for $13 million, bought it back for $5 million. Noble closed the hotel to do some sprucing up and, when he reopened it, refused to hire back any employees who had been union members. Noble has said he didn't hire back any of the old workers because he needed to change the image of the hotel to successfully compete in downtown Minneapolis. There now are no union workers at the hotel.

MINNEAPOLIS
STAR TRIBUNE

More than 100 former Normandy employees say that Noble promised them their jobs back at the time he closed down the hotel for remodeling. They've been on the picket line since August.

The demonstrators caused some incovenience for guests, some of whom were angry. "Why you doing this now?" yelled a man wearing a Buffalo Bills cap. "This isn't our fight."[...]

Most guests, though, seemed neutral on the labor issues and posed in front of the demonstrators as if they were another Twin Cities tourist attraction.

Perennial presidential hopeful Jack Kemp addresses the crowd. Wall-to-wall grey flannel suits suggest another Super Bowl uniform.

Athletes in Action permitted few photographers to cover their early-morning testimonial to the Philadelphia Eagles' Reggie White. The organization's own photographer and I moved freely through the room; others were barred. I peered over businessmen enjoying a hearty breakfast to read the fliers placed at each table. "The Bart Starr Award is given each year to an NFL player whose life models high moral character and leadership on the field, in the home and in the community . . . Athletes in Action is made up of athletes who have a personal relationship with Jesus Christ. This has provided them with significance, purpose and victory in the game of life." For his performance in this arena Reggie White shed his jersey and wore the uniform of the assembled team. General Mills sponsored the event and took advantage of the opportunity to promote Wheaties, The Breakfast of Champions. Table sponsors included corporate giants like AT&T, Cargill, Honeywell, Jostens, Price Waterhouse, and 3M. Immaculate servers worked quickly and quietly to deliver the meal. After watching a video tribute to great "Super Bowl Moments" the president and CEO of Medtronic, Inc. welcomed the congregants. The national anthem followed, and then the invocation. All who approached the podium professed their faith, including star attractions Jack Kemp and his quarterback son, Jeff. The breakfast meeting distilled the Super Bowl's essence: sport, business, religion, and politics, conjoined in patriarchy. The hierarchy ordained in the ballroom resolved all contestation. After the benediction the suits dispersed, soon to resume their ministry in office suites across the country.

Athletes in Action of
Campus Crusade for Christ
welcomes you to
NFL SANCTIONED
Super Bowl XXVI Breakfast

January 24, 1992 7:30 a.m.
Hyatt Regency Minneapolis

Sponsored by: WHOLE GRAIN
WHEATIES
The Breakfast of Champions

Athletes in Action is the sports ministry of Campus Crusade for Christ International. AIA fields competing teams in four sports, including basketball, wrestling, track and field, and gymnastics. AIA also sends teams of high school and college age students overseas every summer, and is actively involved with professional and collegiate athletes and coaches around the world.

Jack Kemp

For thirteen years Jack Kemp was a quarterback for the San Diego Chargers and the Buffalo Bills. He helped lead the Bills to the AFC Championship in 1964 and again in 1965, when he was named the league's MVP. He co-founded the AFL Players Association and was elected President of the Association, a position he held for five terms. Earlier this month, Kemp was honored by the NCAA as the 26th recipient of the Theodore Roosevelt (Teddy) Award.

Mr. Kemp has served as Secretary of Housing and Urban Development since February of 1989. Prior to his appointment to President Bush's cabinet, Mr Kemp served in the House of Representatives from 1971 to 1989.

Jeff Kemp

Beginning his football career in Los Angeles in 1981, Jeff posted his best year with the Rams in 1984, starting the last 13 games and taking them to the playoffs. After five years with the San Francisco 49ers and the Seattle Seahawks, in 1991 Jeff found himself again thrust into the starting position for the injured Jim McMahon. Playing in three of the last four Eagles' 1991 season games, Kemp led Philadelphia to three wins, including a season ending victory over the NFC Champion Washington Redskins.

Off the field, Jeff is a board member for Professional Athletes Outreach and worked in Seattle's inner city with Union Gospel Mission in building a gymnasium for youth.

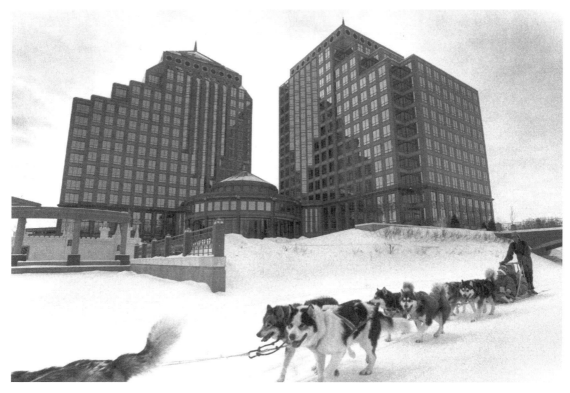

The most lavish of all parties offered an unusual array of entertainment, including sled rides pulled by Will Steger's dog team.

Discovering the whereabouts of private corporate-sponsored Super Bowl parties proved to be a difficult task, and obtaining permission to photograph them was even more problematic. When I read in the Star Tribune *that Marilyn Carlson Nelson was "reportedly hosting what might be Super Bowl weekend's most lavish and most exclusive bash," I saw my opportunity, perhaps my only chance. I tried to tap her desire to tell the Minnesota story, and I appealed to her as one local resident to another. Of course I didn't appeal to Nelson directly; my request was channeled through her personal assistant.*

When I emerged from the car Carlson headquarters confronted me like a surrealist landscape. Sled dogs, snowmobiles, horse-drawn sleighs, cross-country skiers, ice surfers, and ice skaters criss-crossed the snowy expanse. Hovering above this tableau vivant hung brightly colored hot air balloons, pulling against their anchored tethers. A T.G.I. Friday's restaurant assumed the form of a circus tent pitched alongside the frozen pond. The marble interior of the Carlson Tower Rotunda provided the setting for warmer, less athletic pursuits. Mariachis or video games provided entertainment, while a sumptuous array of food and drink, ceremoniously prepared and presented, tempted even the most scrupulous photographer.

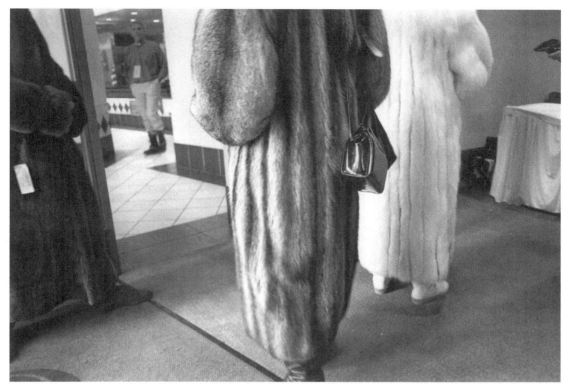

Guests could be identified by their bright yellow identification tags and their party clothes. Those who forgot their furs could borrow or purchase a coat from the rack displayed by Alaskan Furs.

As many as 900 of the highest of high rollers ventured onto Curt Carlson's frozen private lake yesterday for an exclusive party outside Carlson Companies headquarters. A 130-seat TGI Fridays was erected on the lake so party goers could eat and drink. Outside, they rode snowmobiles, a hot-air balloon, horse-drawn sleighs and an eight-dog sled. Former Olympic figure skater Dorothy Hamill gave skating lessons, and polar explorer Will Steger narrated a slide show about his antarctic expedition.

Some praised the advantages of the cold weather. "The germs are all gone," declared Noah Farris of Dallas. But not everyone was dressed for the occasion. Nina Pellegrini of San

MINNEAPOLIS
STAR TRIBUNE

Francisco tried her hand at ice sailing in a full-length white fox fur coat. The party was sponsored by Carlson Companies, CBS and Coca-Cola. The plutocracy was out in force: CBS president Howard Stringer, Curt Carlson, Minnesota Twins owner Carl Pohlad, Northwest Airlines Cochairman Al Checchi, Financier Irwin Jacobs and First Bank Chairman John Grundhofer.

Carlson guests could choose roast turkey or beef from the carvery or observe the chef's preparation of a made-to-order sauté.

We had conceived of ourselves as free agents, independently pursuing our goal to tell our own Super Bowl story. To my surprise, on several occasions my subjects responded to me as if they had hired me. I was considered an employee, a contract photographer. This first became clear to me when I photographed the Toshiba party. The tour organizer took me aside as I was framing a shot of star salespeople lining up for an exquisite buffet dinner. "Don't photograph people eating," she ordered. "Show the revelry! The revelry!" "I will," I promised, as I shrugged her off. The revelry heightened as the salesmen continued drinking, and my feelings of solidarity with the hard-working servers and bartenders increased. As I stood talking with one bartender, an attractive blonde in her early 20s, an inebriated salesman began flirting with us. He didn't seem to mind my camera's flash, but his bearhug momentarily halted my activity. Trying to account for his friend's behavior and evoke goodwill toward them both, another salesman explained that his friend was recently divorced. Our unresponsiveness registered slowly, but before they could feel fully rebuffed the Toshiba group was herded to the next event. After their departure the staff debriefed. As he busily cleared off tables, one busboy announced with disgust, "That guy kept asking me where he could go to get laid!" My new friends insisted on feeding me dinner, and together we regrouped for the next event.

A bartender's forbearance exemplified the positive attributes of Minnesota's workforce.

The Business Bowl

Most of the players rubbing shoulders at the Super Bowl next Sunday won't be wearing shoulder pads.

Although the cast of people attending the big game will certainly be sprinkled with celebrities and titans of industry, most will be favored clients or top sales agents of corporations. They will be quietly wined and dined throughout the weekend by their corporate hosts, who hope to keep them loyal.

Lesa Ukman, editor of IEG Sponsorship Report, a Chicago-based sports marketing newletter that follows the business of sporting events, said corporations see the Super Bowl as a great opportunity for business-to-business marketing.

SAINT PAUL
PIONEER PRESS

"It's a very good entree to people who make buying decisions," she said. "So you host them at the Super Bowl, and you may talk some business while you're there, and then you have a sales representative follow up a week or two later."

But it's also done very quietly—almost invisibly. Many corporations that are more than eager to talk about their sponsorship of the game are mum about their entertainment activities associated with it. And although some of the guests may be using the Super Bowl to prospect for new business, the salesmanship is usually kept low key.

"It's pretty tacky to walk around in a plaid sports jacket with a stack of business cards," said R.T. Ryback, head of the planning committee for the Super Bowl Media Party sponsored by Jostens Inc.

"This is really low sell. There's no question people are trying to do business. The only question is, how sophisticated are they in playing the corporate version of the blushing virgin?"

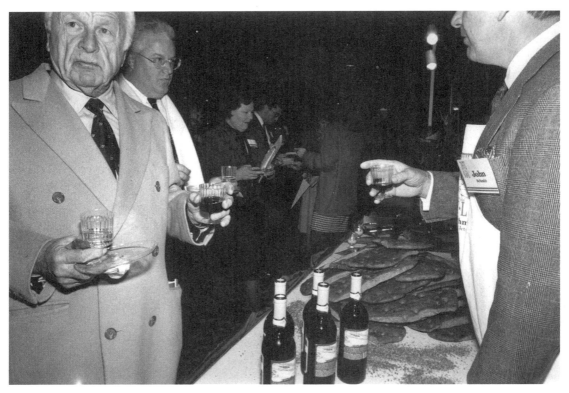

Actor Eddie Albert toured the Taste of the NFL, sampling wines recommended by representatives of NFL cities nationwide.

The Taste of the NFL linked an oxymoronic string of concepts: professional football, haute cuisine, and hunger relief. One chef from each NFL city, paired with an alumnus from each football franchise, presented a "signature dish" to be sampled by event participants. At the Redskins' table, chef Robert H. Kinkead, Jr., of Twenty-One Federal in Washington, D.C., served a wild mushroom strudel, assisted by Redskins' veteran Bobby Mitchell. It was a sumptuous affair, a feast of Super Bowl proportions. Chefs competed to present the most memorable dish, and each creation was accompanied by a different wine. Formally dressed diners moved slowly from table to table, savoring the food and the repartee. In the middle of the room a fragile tower, wine glasses climbing to a peak of ten feet, waited. In a climactic demonstration of skill and opulence, a tuxedoed master of ceremonies, knife in hand, rapidly hacked off the necks of champagne bottles and handed them to his compatriot standing on a ladder above. From this elevated perch a steady stream of champagne poured into the highest glass, filling them all in an elegant trickle-down that rendered the wine undrinkable, due to the broken glass. For the next event, autographed helmets, one from each team, were awarded to the highest bidders. All ticket receipts from the $75-a-head gala were donated to hunger relief agencies. Diners feasted at the Taste of the NFL and thereby fed the hungry. But the homeless would not enjoy a similar feast. The conspicuous consumption linked with privilege would yield only the staple goods that sustain the needy from one day to the next.

Local community college students worked behind the scenes doing kitchen prep work on the morning of the Taste of the NFL.

Weekend belongs to a wave of high rollers.

Meet Dr. Dale Helman, Monterey, Calif., self-described high roller. The 32-year-old neurologist was tooling around the Twin Cities Saturday afternoon in a blue-and-gold chauffeur-driven 1962 Rolls that rents for $1,200 a day.

He's here for the Super Bowl and because he needed someplace to spend some money.

He says he made the trip to the Super Bowl because he needed a $10,000 tax writeoff: "On Dec. 30, my tax accountant said I have 36 hours to get an entertainment deduction." In a New Year's Eve rush, Helman bought four tickets over the phone from Ticket Exchange, a ticket broker in Phoenix, Ariz.

MINNEAPOLIS
STAR TRIBUNE

"I offered him the 40-yard line, but he said it wasn't good enough," said John Langbein, owner of Ticket Exchange. "I finally got him the 50-yard line, 20 rows up." The price: $1,550 a ticket.

Helman wanted only the best seats. He said he'll write the trip off because he's taking three neurologist friends to the game and plans to discuss neurology with them "in the limo. . . . Maybe at halftime we'll talk about the neurology of football injuries." He also went to Minneapolis Veterans Medical Center yesterday afternoon in his limo to interview a neurologist for a position on his staff.

"It is rare that I get a weekend off, but when I get a weekend off I play hard," said Helman, who flew first class from San Francisco on Friday night. He and his buddies went to a Champps sports bar, where they met some Buffalo Bills Cheerleaders.

He calls his visit "clean fun."

He was headed last night to the Taste of the NFL, a $75-a-plate dinner.

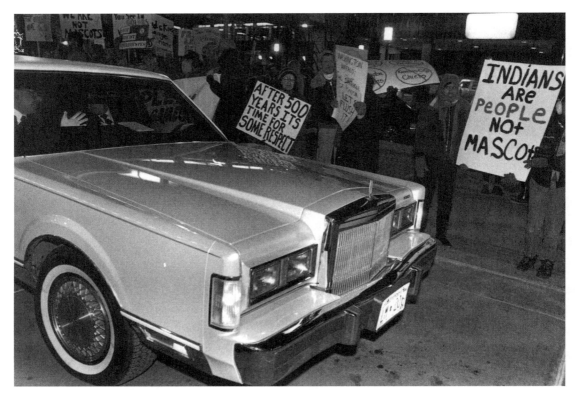

Representatives of the American Indian Movement protested racism in sports outside the lobby of the Hyatt Regency Hotel during the NFL Alumni Awards Dinner.

Despite the many hours I spent on the telephone securing permissions to photograph, I was never able to gain entry to the $1,000-a-plate "NFL Alumni Player of the Year Awards Dinner." This time I was forced to remain outside the ballroom, catching glimpses of those who attended from a perch in the Hyatt Regency lobby. I had plenty of company. Outside the hotel, bundled up against the cold night air, a contingent of protestors from the American Indian Movement picketed. Limousines dispatched fur-clad passengers at the door, where they were shielded from the din of native voices. Chants of protest caused only a momentary diversion for the visitors who rushed past, seeking the lobby's warmth. Inside, ESPN was broadcasting live, while celebrity watchers jostled one another for an off screen glimpse of their heroes. I found a seat with a view, roosting alongside other observers. A woman dressed in an army fatigue jacket appeared and asked if she could squeeze in; it was a tight fit, but the crowd shifted to accommodate her. "Who've you seen?" she asked. "No one really. Oh, Andy Rooney from 60 Minutes." We watched the parade silently, until a uniformed police officer approached and addressed her. "Sergeant said we can leave, since the AIM protestors have left the area," he told her. The protest was done for the night. After the officer withdrew I turned to reassess my companion. She met my gaze and offered, "You know, I believe in what they're saying, these people, about the names." She smiled a thin, weary grin and added, "But I really wish they would say it during someone else's shift."

Washington Redskins
Pro·Football Inc.

JACK KENT COOKE
CHAIRMAN OF THE BOARD

January 15 1988

Mr Philip St John
Concerned American Indian Parents
2016 16th Avenue S
Minneapolis MN 55404

Dear Mr St John

With some interest, and I must say, some amazement, I read your letter of January 6 which arrived at my farm today.

Amazement? Yes, because the Redskin football team represents one of the most admired and respected organizations in America, in or out of sports. After 51 years, I can hardly conceive of this fine organization carrying any title other than the one it so proudly bears.

I find it difficult to accept your statement that the name, "Redskins" is "racist, derogatory and demeaning to the American Indian". Frankly, no more than I resent the appellation of "Canuck" (and I am a former Canadian); nor others of my friends who are called "Brits"; nor still others who are called "Aussies"; nor our good neighbors the "Crackers" from Georgia; nor those esteemed "Tarheels" from North Carolina; nor the "Nanooks" from Iceland; nor the "Bears" from Russia; nor the "Cajuns" and "Creoles" from Louisiana; nor the "Cornhuskers" from Nebraska. Oh, heavens, I could go on and on; but I won't.

Basically, I want you to know that I am totally out of sympathy with your project. Nevertheless, I thank you for your letter.

Best wishes

Yours truly,

Jack Kent Cooke

JKC/ald

Guards secure the ballroom of the Radisson Hotel, barring nonpaying autograph hounds and celebrity watchers from the $1,000-a-plate festivities taking place within.

The dizzying pace set by nonstop entertainment kept me in motion all week. I had covered event after event, moving through the barriers erected to keep out those who didn't pay or didn't belong. My press pin and my status as a professor allowed me to pierce the protective armor fastidiously maintained throughout the city. I had almost forgotten the feelings of insignificance, inadequacy, anger, and resentment that exclusion often yields. But like the NFL, the corporate elite, and the Super Bowl XXVI Task Force, I had erected my own set of barriers. Safe behind my camera shield I tried to fend off the seductions of fine food and drink, the allure of expensive objects, the fuzziness produced by too much small talk and too many parties. I worked hard to avoid the traps set by people in power, and responded with strategies to avoid telling the same old story. Fatigue threatened my resolve. My irregular return to home and family provided crucial reality checks. While making bag lunches and rifling through my kids' school bags I compared my everyday life with the image of reality constructed by the Super Bowl. Strong men at the helm, with glamorous women by their sides. The accomplished are mandated to lead, others must serve. Hard work and spirituality reward us all. Together we celebrate the master plan. My reverie and my sandwich making halted abruptly when I discovered we were out of bread.

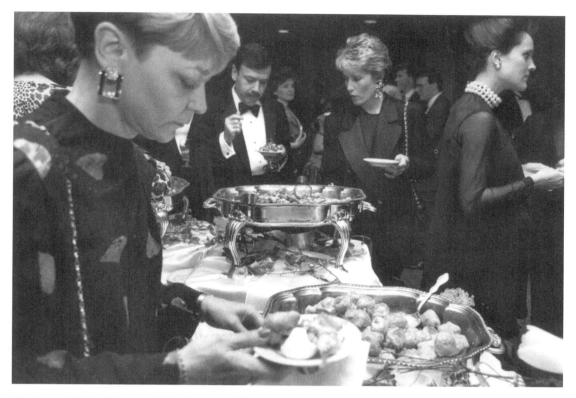

Guests survey the hors d'oeuvres at Rashad on Ice, a celebrity "roast" of former Minnesota Viking Ahmad Rashad.

Menu
Cream of Wild Rice Soup
Kentucky Bibb Lettuce served with Julienne
of Vegetable Roots with a Walnut Vinaigrette Dressing
Grilled Filet of Beef with Green Peppercorn Sauce
and
Grilled Filet of Salmon with Dill Sauce
Baked Stuffed Potato
Haricort Verts Baby Carrots
Bailey's Irish Cream Torte with Cream Anglaise
Coffee Wines by Fetzer

Order of Ceremonies
8:00 Dinner
Wintery Wit — Bill Murray
9:15 — Rashad on Ice
10:28 — 2-minute warning
10:30 — Zamboni on the Ice!

In lieu of snowballs, please take your complimentary
football cards and champagne glasses and toast Superbowl XXVI.

Consummation

Each year the Super Bowl consummates the NFL season. Football's "spectacle of spectacles" commingles the past and the present as conference winners vie for the coveted Vince Lombardi Trophy and compete against records set by past Super Bowl contenders. In 1992 members of the winning team each earned $36,000 and received a diamond-studded ring commemorating the victory. The NFL paid losing players $18,000 each for their role in the multimillion-dollar extravaganza. The Super Bowl celebrates the history of the league and its crowning achievement—husbanding the lucrative industries allied with professional football. The mass media have provided a vehicle elevating the Super Bowl to a position of such cultural prominence that Michael Real has labeled it a "mythic spectacle." He writes, "In the classical manner of mythical beliefs and ritual activities, the Super Bowl is a communal celebration of and indoctrination into specific socially dominant emotions, life-styles and values."[1] The time, effort, and money lavished on hosting Super Bowl XXVI corroborates assertions that the Super Bowl's significance far surpasses the outcome of the game.

What does the Super Bowl represent? Attempts at explication yield multiple intertwined narratives, reflecting the cultural complexity of an outwardly simple event. At the conclusion of his labor at "reading football," cultural historian Michael Oriard suggests the difficulty of definitive interpretation: "In the 1990s as in the 1890s, football generates multiple narratives about work, gender, race, success, many of our most hopeful and disturbing fantasies. Print and electronic media powerfully influence our ideas about these matters, yet without resolving our conflicting beliefs into a single master narrative."[2] Real, among others, forwards a less equivocal reading of the event.[3] Reflecting the culture of the power elite that conceived it, "American football is an aggressive, strictly regulated team game fought between males who use both violence and technology to win monopoly control of property for the economic gain of individuals within a

nationalistic, entertainment context."[4]

As the NFL's annual finale, each Super Bowl can be viewed as a momentary historical endpoint, a position from which to assess the evolution of football and its cultural significance. Marking 1992 as professional football's centennial, NFL Commissioner Paul Tagliabue seized the opportunity to recall the origins of the sport in *The NFL and You 1992-1993*: "On November 12, 1892, a former All-America guard from Yale named William (Pudge) Heffelfinger was paid $500 by the Allegheny Athletic Association to play in a football game against the Pittsburgh Athletic Club. Thus, 100 years ago, Pudge Heffelfinger became the first professional football player. The centennial of the Pudge Heffelfinger story presents an opportunity to reflect on the distance from there to here. Quite obviously we have come a long way."[5]

Tagliabue's brief recitation of history glosses over the implications of the "Heffelfinger story," a narrative that encapsulates the evolutionary change to which he refers.

The proliferation of organizations like the Allegheny Athletic Association and the Pittsburgh Athletic Club coincided with late-nineteenth-century advocacy of amateur athletics. Social reformers considered athletics a useful means of channeling the leisure-time activities of working-class and immigrant youths. Organizations like the YMCA spread through cities across North America during the late nineteenth century, promoting the moral and spiritual benefits associated with supervised athletics, a wholesome alternative to the vulgar commercial amusements increasingly available to urban residents. Athletics provided an opportune hegemonic tool:

> By the end of the century, many reformers believed that sports could be a socially stabilizing force that would help Americanize foreigners, pacify angry workers, clear the streets of delinquents, and stem the tide of radicalism. Sports could deflect tensions away from an oppressive social structure and channel energy into safe activities that taught the modern industrial values of hard work, cooperation, and self-discipline, and thereby help secure the social order.[6]

The benefits believed to result from athletic activity cut across class boundaries. While offering a mechanism for the social control of inferior classes, elites viewed sport as a training ground preparing young men to assume the reins of power. Available opportunities to prove one's masculinity evaded the post-Civil War generation, with no opposing armies to combat, nor frontier territory to subdue. Orators promoted sport as the moral equivalent of war, an arena in which men could experience combat, heroism, glory, and the injury of the battlefield. Viewed as a competitive testing ground for masculinity, sport advocates averred that athletics undercut the corrupting feminization of materialism. Theodore Roosevelt, a champion of the value of athletics, articulated this view in his essay of 1893, "The Value of an Athletic Training":

> In a perfectly peaceful and commercial civilization such as ours there is always a danger of laying too little stress upon the more virile virtues—upon the virtues which go to make up a race of statesmen and soldiers, of pioneers and explorers by land and sea, of bridge-builders and road-makers, of commonwealth-builders—in short, upon those virtues for the lack of which, whether in an individual or in a nation, no amount of refinement and learning of gentleness and culture, can possibly atone. These are

the very qualities which are fostered by vigorous, manly out-of-door sports."[7]

Football provided an appropriate vehicle through which to activate these ideals, as Roosevelt himself proclaimed: "In life, as in a foot-ball game, the principle to follow is: Hit the line hard; don't foul and don't shirk, but hit the line hard."[8]

GRIDIRON FOOTBALL — English colonists brought games resembling football with them to the American continent. Chronicles of Virginia in 1609 mention a game played using an inflated bladder for a ball. In 1685 two Massachusetts towns reportedly engaged in a football match. Such games proliferated, though players often negotiated the rules spontaneously. By the nineteenth century football had become a popular intramural collegiate sport, organized, trained, coached, financed, and played by student enthusiasts. Two variants of the game existed: one, like soccer, prohibited touching or carrying the ball, while the so-called "Boston Game" resembled rugby and allowed carrying and running with the ball. A group of college teams negotiated a common set of rules in 1867, and in 1869 Princeton and Rutgers played the first formal intercollegiate game. The rules allowed twenty-five men on each team; the first team to score six goals won. As in soccer, players could not throw or run with the ball. The rules changed again in 1876 when Princeton, Harvard, Yale, and Columbia formed the Intercollegiate Football Association and adopted a style of play nearly identical to that of the English Rugby Union. Later that year, Yale won the first college football championship.

Sport historians consider a member of Yale's victorious team, Walter Camp, to be the patriarch of American football. His innovations transformed football into a uniquely American game, distinct from its predecessors, soccer and rugby. At the annual rules convention in 1880 he introduced the scrimmage; in 1882 he initiated new styles of blocking, tackles below the waist, and the use of downs to gain yardage on a demarcated turf—the gridiron. Teams responded to tackling with offensive "mass plays" and "flying wedges" in which a large number of players drove into the opposing team's defense in order to gain the five yards needed to maintain possession of the ball. The violence of an already injurious activity escalated, exhilarating spectators while provoking an outcry among educators and reformers, who called for the abolition of the game. Subsequent (and temporary) rule changes outlawed mass plays and momentarily quelled controversy regarding the game's extraordinary brutality.

During this period the commercial press entered the fray. By exploiting the narrative potential of athletic events, newspapers both expanded circulation and helped to institutionalize sports. Led by Joseph Pulitzer and William Randolph Hearst, press coverage of college football increased through the 1880s and 1890s, filling the void left in the fall by the absence of baseball and horse racing. Boosting the entertainment value of their competing papers, Pulitzer's *World* and Hearst's *Journal* thrust football contests between Ivy League athletes before a burgeoning mass readership. The Thanksgiving Day Intercollegiate Football Association championship, held annually in New York City, quickly became an elite social event and the subject of considerable newspaper copy, complete with dramatic illustrations. By Thanksgiving Day, 1896, an estimated 120,000 players participated in 5,000 football games held across the country.[9]

In 1905 a new crisis beset the game—eighteen players died in action on the gridiron, and

the resulting public clamor jeopardized football's future. In response to increasing calls for the abolition of the game, fueled by sensational reports in the press, President Theodore Roosevelt prompted the formation of the Intercollegiate Athletic Association for the purpose of reforming and thereby saving the game. Roosevelt had already professed his own ardent support for football in several essays, and regarding the risk of injury he opined, "The sports especially dear to a vigorous and manly nation are always those in which there is a certain slight element of risk. Every effort should be made to minimize this risk, but it is mere unmanly folly to try to do away with the sport because the risk exists."[10] The popularity of football shared among the President, football's players and promoters and the press insulated the game from its most vehement detractors. To assuage its critics, football promoters tinkered with the rules yet again, and introduced the forward pass to open up play of the game and reduce its brutality.

Football swept the country. Amateur clubs and high school teams proliferated as football diffused from elite eastern colleges to urban sandlots. As increasing numbers turned their attention to the sport, emphasis began to shift from the thrill of play as experienced by participants to the elaboration of strategies designed to win games, producing a rousing show for spectators on the sidelines. By the 1890s college football required increasing expenditures but returned significant revenues, and control shifted from students to alumni who managed collegiate athletics and exploited football as a fund-raising vehicle. Alumni built colossal stadiums, the stages upon which their players would perform. By the end of the century the transformation was complete. American football had emerged—an organized, revenue-producing bureaucracy, administered by coaches, trainers, and referees. Walter Camp played an instrumental role in this metamorphosis, making an efficient machine of football's spontaneity.

Camp began his football career in 1876 as a member of the Yale team, and he extended his tenure through two years of medical school. Even after he left Yale to assume a position at the New Haven Clock Company he huddled with student coaches in the evenings. Camp succeeded in both worlds simultaneously: he became the Clock Company's president and chairman of the board, and football's leading tactician and promoter. Camp made use of the lessons he learned on the playing field of American business and he made his views known through the publication of several influential tracts on football. Camp conceived of the game as a team effort guided by an expert manager—the coach. Team play, as Camp saw it, might require the sacrifice of "individual brilliancy" in the service of organizational effectiveness, in order to ensure the "securing of goals and touchdowns."

Camp articulated his view of the relationship between business and football in his essay written in 1891, "Team Play in Football": "If ever a sport offered inducements to the man of executive ability, to the man who can plan, foresee, and manage, it is certainly the modern American foot-ball."[11] In the world of industry, Camp's contemporary, Frederick Winslow Taylor, introduced principles of "scientific management" aimed at maximizing the output of American manufacturing. Camp modeled his approach to coaching football after Taylor's recommendations. According to Oriard, "Camp's version of scientific management could be summarized in a parallel list: the devising of plays, the training of players for the positions that suit them; the cooperation of coach, captain, and quarterback with the rest of the players so as to assure common purpose; and the

distribution of responsibilities according to position and ability. Taylor made a science of organizing physical labor; so did Camp. Taylor distinguished the needs for brain and for brawn, and assigned them accordingly; so did Camp."[12] According to this view, football also tested the managerial skills of coaches; those who could field the most effective work force would win.

Under Walter Camp's stewardship Yale dominated college football. Camp's approach found adherents nationwide, among coaches seeking to emulate the winning record he chalked up. In 1889 Camp again exerted his authority, and together with sportswriter Caspar Whitney, he instituted the All-American team, recognizing the most distinguished players of the year. By initiating this annual rite Camp designated standard-bearers against whose accomplishments future players would be measured, and about whom football's history could be spun. Until his death in 1925, Camp played an instrumental role in football's development and institutionalization and spread the football gospel nationwide. In the shadow of the explosive college football phenomenon, amateur clubs continued to compete, emulating the standards evolving on the college gridiron. On occasion they enlisted the assistance of better-trained collegiate players to gain a competitive advantage on the field. Among them, the Yale All-American Pudge Heffelfinger epitomized Walter Camp's approach to football.

PROFESSIONALIZATION In 1892 Pudge Heffelfinger brought the legacy of Camp's system to the Allegheny Athletic Association, if only briefly. Planting a ringer like Heffelfinger on the team roster, an act lionized one hundred years later by football's current steward, Paul Tagliabue, undermined the ideals reformers had hoped to activate through amateur athletics. But amateur ideals often broke down as they crossed class boundaries. Purists considered playing well, not winning, the ultimate goal of participation. They maintained that commercialization corrupted athletics, and sanctions awaited collegians caught engaging in sports-for-hire. But transgressions occurred, sometimes with the knowledge of purists who nevertheless hungered for an important victory. Subscription to the "amateur code" marked a boundary between elites who could afford to play at their leisure, and men for whom work at athletics offered new economic opportunity.

As the value of winning overshadowed the perceived benefits of participation, amateur clubs began paying more and more players to join their ranks until the practice became commonplace. In 1893, far from the scrutiny of eastern ideologues, the Allegheny Athletic Association paid three men a salary of $50 each per game. By 1895 they fielded a team of fully salaried players, creating new opportunities for skilled athletes. Teams recruited former college players as well as current student athletes, who played under pseudonyms to prevent detection and protect their college eligibility.[13] Semiprofessional football played by athletic organizations lacked the luster of the college game; contests drew small crowds, and players earned modest salaries and scant prestige, but local games brought a new diversion to the small industrial towns in western Pennsylvania and the Midwest, where football took root and flourished.

Pittsburgh became a football hub, the product of activity generated by local steel magnates' corporate teams. These canny industrialists seized upon organized athletics to engineer employee loyalty and stave off unionization while increasing profits and

creating a positive public image. Steelworkers filled out the eleven man roster of the Braddock Carnegies; during the season they were excused from millwork and received bonuses recompensing their efforts. Players for the Columbus Panhandles worked as mechanics for the Pennsylvania Railroad. At the end of the six-day workweek, Saturday afternoon at 4, they caught the train for an out-of-town contest and returned in time for work on Monday morning. By 1903 the game moved west to Ohio and continued on into small Midwestern towns, where blue-collar workers found a limited range of leisure-time pursuits. Records indicate the existence of thirty-three teams by 1920, in cities like New York, Boston, and Chicago as well as smaller towns like Canton, Decatur, Kenosha, and Minneapolis.[14]

Following the lead set by college players in the 1870s, the organizers of a few semiprofessional teams met in an auto showroom in Canton, Ohio, in 1920 and agreed to form a football league. Fourteen teams entered the league at a cost of $100 each, a fee no team actually paid. The American Professional Football Association drew its member teams from the Midwest; the professional league reached only as far east as Rochester and Buffalo, New York, a reversal of the geographic dynamic characterizing the diffusion of the elite college game. In 1922 the association changed its name to the National Football League.

Despite the best efforts of team owners to promote the game, instability plagued the league. Team numbers rose and fell, and game schedules fluctuated. The Chicago Bears, one of the best teams during the early 1920s, typically drew only five thousand spectators, even though general admission tickets cost only fifty cents. Teams located in smaller towns struggled to survive, and by 1934 Green Bay was the only small city represented among the league's teams.[15] Meager profits rewarded some owners while others faced significant losses, compelling them to rely upon other sources of income or exploit political connections to stay afloat. Some owners of early franchises endured the League's rocky start supported by the proceeds of successful gambling operations:

> Two owners heavily involved in local politics were bookmaker Tim Mara, a Tammanyite who founded the Giants in 1925, and gambler Arthur Rooney, a Pittsburgh pol who established the Steelers in anticipation of the passage of laws permitting Sunday sports. A third NFL patriarch with questionable associations was Charles Bidwell of the Chicago Cardinals, owner of Sportsman's Park. Bidwell's partner in the track was his attorney, Eddie O'Hare, a director of the Cardinals who had fronted for Al Capone at the Hawthorne Dog Track.[16]

In an attempt to boost the profitability of his franchise, in 1925 George Halas, owner of the Chicago Bears, recruited "Red" Grange, a nationally renowned running back for the University of Illinois. Grange's unusual contract, negotiated by his agent, Charles C. Pyle, tied his salary to the Bears' gate receipts—his first appearance with the team drew an extraordinary 38,000 spectators. In addition to the role Grange played on the field, Pyle negotiated product endorsements, public appearances, and a movie contract, transforming his client into a sports "personality."[17] Grange generated positive publicity for the NFL and helped to stabilize the league's financial base.[18]

By the 1930s the volatility of the league's first decade subsided. To ensure a viable

economic base small-town teams ceded to city franchises capable of drawing larger crowds. The sport gained respectability and most college stars chose to continue their football careers with the NFL. In 1936 the league conducted the first "college draft." With professional football firmly entrenched as a profitable spectator sport, a rival league emerged in 1946, guided by a new set of football entrepreneurs who hoped to cash in on the market created by NFL pioneers. The All-American Football Conference launched teams in eight cities, but after four seasons the NFL absorbed its competition, adding three of the rival franchises and consolidating the NFL's own domination of professional football.

EXPANSION—FROM THE STADIUM TO THE LIVING ROOM

During the late nineteenth and early twentieth centuries Americans made and re-made football, crafting a controlled, commodified spectacle out of a spontaneous, aggressive game. The joint activities of players, coaches, owners, the public, and the press gave the game its particular contours, yielding a unique American industrial product. With the introduction of television, the NFL seized a new opportunity to market its product to an even larger public. In 1950, the Los Angeles Rams became the first team to televise the entire season's games. The following year, the DuMont Network paid the NFL $75,000 to televise the League championship to a national audience. The NFL and broadcasters both benefited from the newly forged alliance. Television's success depended upon the availability of popular programming, and the NFL offered the raw material from which broadcasters manufactured a new object, tooled to the medium's specifications. NFL commissioner Bert Bell allowed the first and most crucial in a series of modifications in play—the introduction of television time-outs, allowing the insertion of advertising that interrupted the flow of the game.

The Sports Broadcasting Act of 1961 marked the first in a series of legislative accommodations to the burgeoning business of professional sports. The legislation determined sports leagues to be unified entities exempt from antitrust regulations, thereby permitting the NFL to negotiate broadcast rights for all its franchises. The Sports Broadcasting Act solidified the NFL's bargaining position and the League was able to negotiate an advantageous broadcasting agreement with CBS. Along with a new source of programming, the television industry acquired access to football's audience—predominantly male and reasonably affluent.[19] Demographic research led broadcasters to conclude that it could sell another commodity—its viewers—to advertisers. Network revenues increased, and the ensuing competition for NFL broadcast rights drove the value of negotiated contracts from $200,000 in 1960 to $4.5 million in 1962. Over the next two years Nielsen ratings jumped 50 percent, and in 1964 the NFL parlayed those numbers into a broadcast contract with CBS worth $14 million per year.[20]

Entrepreneurs sidelined by the CBS/NFL monopoly on professional football mounted their own offensive strategy in 1960. A broadcast agreement with ABC already in hand, Lamar Hunt (owner of the Kansas City Chiefs) launched a new eight-team league, the American Football League, bringing the potential for profitable football franchises to cities locked out of the action by the NFL. Access to television kept the AFL afloat and produced advertising revenues for ABC, helping to shore up the economic base of the weakest broadcast network. Bids for broadcast rights escalated. In 1965 NBC competed with CBS for NFL football and lost, but the network would no longer be denied access to the game. NBC regrouped and successfully negotiated a $42 million five-year contract

with the AFL, a package that approached the figure CBS paid the NFL. The colossal new broadcast contract catapulted the AFL into direct competition with the NFL, and the fledging league began to sign contracts with top NFL players, raising salaries all around. With its new contract in place, NBC had, in effect, signed on as the AFL's co-promoter, assuring the league's survival and the revenues it could generate. ABC didn't regain its foothold until 1970, when the network successfully introduced prime-time broadcasts on Monday Night Football.

Guided by the competitive values instilled by the game, the NFL met the AFL's challenge head-on, and absorbed its rival by 1966, agreeing to expand the league to twenty-six teams by 1970. The two leagues maintained separate identities and schedules, and agreed to hold the first NFL-AFL World Championship, later called the Super Bowl, beginning in January 1967. Finalizing the merger, CBS and NBC agreed to split the league broadcast contract. In 1969, the NFL reorganized and formed two thirteen-team conferences, the American Football Conference, composed of former AFL teams (plus three from the NFL: Baltimore, Cleveland, and Pittsburgh), and the National Football Conference, made up of the remaining NFL teams.

During the 1960s television transformed professional football into America's premier spectator sport, a position the NFL proudly asserts, using vividly illustrative charts and graphs, in *The NFL and You, 1992-1993*. Since 1960 outsiders have attempted to challenge the NFL's lucrative monopoly, but the league continues to forge alliances within the rapidly changing broadcast industry, preventing incursions. Since the AFL's successful penetration of the NFL stronghold two new leagues have been launched but quickly failed: the World Football League operated from 1974 to 1975 and the United States Football League from 1983 to 1985. In 1986 the USFL brought an antitrust challenge to the courts, charging that the NFL held a monopoly on professional football due to its control over network broadcast rights payments. The jury found that the NFL does, in fact, hold a monopoly on professional football, but that the USFL's bankruptcy resulted from financial mismanagement. The jury awarded the USFL one dollar in damages, and when the verdict withstood appeal the USFL disbanded. The courts maintained the status quo, squelching the real threat posed by the USFL: escalating player salaries as a result of increased competition for their labor.

By 1989 twenty of the twenty-eight NFL team owners appeared on *Forbes* magazine's list of the four hundred wealthiest Americans. Team owners have amassed their wealth as CEOs of regional franchises representing what has evolved into a multimillion-dollar media-entertainment conglomerate. Acting together, NFL owners restrict expansion of the league, and by making football teams into scarce resources they increase the value of the franchises each controls. The monopolistic practices of the league result in a cartel that benefits the owners in a variety of ways.

Successful teams require the labor of skilled athletic workers, but limiting the number of outlets for their specialized skills enables owners to hold down wages. The rise and fall of rival leagues exemplifies this point: in each instance players' salaries climbed due to increased demand, motivating the NFL to act quickly and shut them down. The NFL's reserve clause restricted inter-team competition for players, all but eliminating free agency until 1993, when the NFL Players Association negotiated a complex veteran free

agency agreement. Although player salaries may seem high, football careers average less than four years, and many players suffer injuries that diminish post-NFL earnings. Compared to the salaries of other entertainers or CEOs, whose careers promise long-term incomes, player salaries appear modest, especially considering the revenues they generate. Buffalo Bills quarterback Jim Kelly offers a case in point:

> In 1986 the Buffalo Bills invested some $1.5 million in quarterback Jim Kelly. The financial results of this investment were impressive:
>
> - Average home attendance increased by 31,121 fans.
> - At $25 per ticket, the increased revenue was $778,025 per game.
> - $778,025 x 8 home games = $6,224,200 for the season.
>
> In other words, for a $1.5 million investment, the Bills got better than a 400% return![21]

Team owners cash in on the scarcity of franchises by charging a high price for the entertainment they offer fans, who pay in a variety of ways. Rising ticket prices, parking costs and stadium concessions discourage many fans from attending games, but corporate ticket purchases qualify as a tax-deductible business expense—fans forced to watch the game at home subsidize corporate ticket holders with their tax dollars. Municipalities underwrite many of the costs incurred by franchises, and taxpayers eventually foot the bill. Recent threats of team relocation have generated skirmishes between city officials and team owners, and have triggered critical coverage by the press, bringing these hidden costs to the public's attention.

Municipalities have allowed team owners to finance new stadiums with public funds, revenue bonds to be repaid with the income generated by the new facilities. But most stadiums don't even produce enough revenues to cover their operating costs; the municipality and its taxpayers end up shouldering the burden of the loans. When local governments own sports facilities, team owners pay no property taxes, maintenance costs, or insurance, although rent covers a proportion of these expenses. Unencumbered by the facilities they use, owners can relocate their franchises more easily, allowing them to leverage additional concessions from the communities competing for them. Team owners have discovered a new tactic to increase their profit margins—selling luxury skyboxes to corporations—and some have demanded expensive renovation projects or new stadiums, setting in motion the next round of unreimbursed public spending.

Few municipalities willingly rebuff franchise owners' requests for improved facilities. Politicians, corporate elites, and community boosters, especially those who derive profits from the presence of professional sports franchises, proclaim the economic and psychological edge "major-league cities" possess, and endeavor to raise support for capital expenditures. But economic analyses fail to support such benefit claims: "most social and economic analyses have concluded that the prime beneficiaries of these sport facilities are a small group of wealthy individuals and that those most likely to bear the costs are low-income citizens."[22] A state-of-the-art sports arena may generate pride, but economists suggest that direct and auxiliary costs produce no significant positive impact on a city's economy, drain funds from other municipal projects, and result in a net loss for

municipal treasuries. As owners sever local ties and move their teams to more profitable or more pliable markets, empty taxpayer-constructed facilities become hometown liabilities.

State subsidies make team ownership a winning proposition. Government-supported antitrust exemptions yield a powerful cartel, enhancing the NFL's bargaining position in negotiations with the networks, with players and staff, and with the communities fortunate enough to attract professional franchises. Since the NFL is the sole producer of professional football, the league attracts sponsors and licensees hoping to ride the crest of the sport's nationwide popularity. Television advertising revenues buttress the league's dominance, and state subsidies support the mutually beneficial transactions between the NFL, the networks, and corporate sponsors, allowing corporations to write off advertising expenditures as tax-deductible business expenses. Tax laws even enable NFL owners to depreciate players, the human assets whose value contributes to team owners' rankings among the wealthiest Americans.

Like other profitable corporate enterprises the NFL has gone multinational, thrusting its product into the international arena. Europe, Asia, and Latin America enticed the League with untapped markets. Reversing the colonial importation of football from Europe and Great Britain, the NFL test-marketed American football through the British broadcast of Super Bowl XI in 1971. Subsequent Super Bowl broadcasts and preseason exhibition games set the stage for future incursions. In 1982 Britain's Channel 4 introduced edited compilations of regular-season NFL play, complete with rock 'n' roll soundtrack and fast-paced graphics, broadcast for seventy-five minutes a week. By the 1987-88 season the audience for the program reached 3.7 million. Magazines covering American football have flooded the market and succeeded in securing a faithful readership.

As in the United States, participation in football set the stage for future commodification and spectatorship. Two semiprofessional leagues emerged in Britain in 1984, joining forces the next year as the thirty-eight team British American Football League. Capitalizing on the gathering momentum, Anheuser-Busch organized its own semiprofessional Budweiser League in 1986. By 1988 the number of teams playing Budball increased from the initial seventy-two to nearly two hundred. Other multinationals signed on as sponsors: American Express, Johnson & Johnson, Toshiba, Minolta, and Hitachi.[23] In 1990 Channel 4 initiated live-action coverage of the conclusions of two regular-season NFL games each Sunday, sponsored by Anheuser-Busch; in 1992 the Nippon Television Network premiered three weekly television shows about the NFL.

Hoping the moment had arrived for the export of football, the NFL introduced a new professional league, targeting Great Britain, the European continent, and Canada for the development of franchises. Using a characteristic military metaphor the NFL announced: "to complete the overseas invasion in 1991, the NFL sponsored the birth of the World League."[24] The NFL planned to market goods as well as games, and the league's subsidiary, NFL Productions, promoted sales of logo apparel for adults and children, magazines, calendars, posters, mugs, clocks, watches, and snack foods. The NFL launched the WLAF with a $28 million initial investment, and the new league garnered an initial $14.5 million television contract, but a cash-flow crisis required a further

investment of $500,000 from each NFL franchise, signaling the need for an official time-out. At the end of the 1992 season the World League of American Football suspended play due to significant financial losses. The NFL faced its first real defeat, vanquished by an intangible rival—cultural difference. The NFL intends to resume foreign play sometime in the future, to fully exploit the profit potential that awaits.

At its centennial mark, 1992, American football arrived at a new threshold. During the hundred years since professional football insinuated its way into clubs ostensibly devoted to amateur competition, the sport has spread across the country and taken root; football is firmly implanted in the American cultural landscape. Its success has been so complete that football has overgrown its borders, spurring the NFL to seek fertile new ground in which to sow new franchises and establish new markets for licensed goods. With the invasion launched by the World Football League the NFL hoped to establish its own colonial empire. Initially conceived as a leadership training regimen, organized football has diffused from the elite confines of Ivy League universities to living rooms around the world, a commodified spectacle consumed from the immobilizing comfort of the couch, washed down with a six-pack of Bud. Nineteenth-century social reformers who advocated sports could have scarcely imagined the route that football has traveled. "Quite obviously we have come a long way," Paul Tagliabue wrote, on the occasion of professional football's centennial. Have we?

GRIDIRON HEGEMONY

Tracing football's historical trajectory incontrovertibly demonstrates its metamorphosis from a game, spontaneous and nonutilitarian, into a carefully managed, lucrative (for owners), high-risk (for players) business enterprise. No one questions the fact that professional football has become big business, but it remains curiously cloaked in anachronisms. We still call professional franchises "ball clubs," alluding to the amateur athletic associations of the nineteenth century. The term "skilled athletic worker" more accurately describes the activities of "players," who have become cogs in the outsized corporate machinery employed to produce a season of football. The pleasure attending play seems a distant concept when supersized athletes take the field wearing protective armor, their actions directed from the coaching staff on the sidelines, with painkillers, physicians, and state-of-the-art facilities ready to dispense specialized sports medicine and return them to action.

Team names suggest a bond with the communities in which they do business; it's our team, the home team, or America's team. We act as if the Washington Redskins belong to the people living in the D.C. area, not Jack Kent Cooke, whose personal fortune, amassed first in the media industry, now amounts to more than $1.25 billion. The loss of a team or failure to attract a professional franchise proclaims a city's inferiority: it's not a "major-league city." We accept the label, Super Bowl—why not use a more descriptive title like the Coca-Cola Bowl? College bowl games bear the names of their corporate sponsors, yielding such alliterative gems as the Blockbuster Bowl. New arenas, like the Target Center in Minneapolis, are christened with the names of the corporations financing their construction. Professional football eschews these telltale corporate monikers in favor of its own imprimatur—NFL.

What purpose do these misleading anachronisms serve? What ideas do they perpetuate? Writing in 1973, sport sociologist Harry Edwards advanced the view that sports function

politically, perpetuating right-wing ideologies:

> While, unlike the political institution, sport is not directly involved in political implementation, it does share with the polity the function of disseminating and reinforcing values that are influential in defining societal means and in determining acceptable solutions to problems, that is, goals to be attained. The fact, however, that sport as an institution is involved only with value dissemination rather than implementation means that its pronouncements need not stray from ideal values. For it is only within those institutions concerned with the actualization of political values in the general society that responsible persons of necessity must show flexibility in terms of their guiding ideology.[25]

Edwards articulates what he calls the "sports creed," commonsense assumptions regarding the value derived from participation in sports. The creed echoes many of the sentiments set forth during the late nineteenth century, and they reverberate today, a series of well-worn truisms.

Sports build character; those who participate are clean-cut, upstanding, wholesome. Team sports teach loyalty and altruism, absorbing the individual into the corporate body. ("There is no 'I' in team.") Sports inculcate respect for discipline; team members appreciate the need for external authority and social control, embodied in coaches, the front office, and the league. Competition on the playing field and performing under duress prepare athletes for the challenges of everyday life. Participation yields courage, perseverance, aggressiveness—fortitude. These experiences develop leadership ability, and athletes serve as positive role models for others. Anyone can attain these positive results because sport recognizes athletic ability, not social class—sport is democratic. Play at sports produces physical fitness, the development and maintenance of a healthy body, and by extension, the vigor to lead. Sports inculcate mental fitness. Excellence in sports and piety are linked; religious devotion improves athletic performance. Athletic events begin with the national anthem, proclaiming their nationalism, and the flag waves prominently overhead. Adherence to the creed yields success—teams governed by these precepts chalkup more wins, a testimonial to God and country.

The creed mythologizes the value of sports, but scrutiny belies these claims, exposing the hyperbole, if not the function, of the commonsense ideals it sustains. The memoirs of former professional football players and statistics compiled by journalists and social researchers lead to more grim conclusions about the experience of professional play and the values disseminated on the field. Player memoirs tell tales of drug and alcohol abuse, of psychological mistreatment and physical injuries exacerbated by overzealous coaches. Walter Camp may have learned leadership on the gridiron in the 1870s, but the pawns moved about on the contemporary coach's chalkboard learn to follow orders. The action on the field mimics the hierarchical organization of the corporation, and does more to perpetuate inequality than offer a route to social mobility.

When fans watch football games they see aggressive combatants competing for a hard-won victory; the front office views NFL players as depreciable assets. Publicity shapes players' endeavors into tales of athletic heroism, but the NFL takes a more pragmatic approach and treats its workers, like so many other corporate employees, as replaceable

Super Bowl
America's Premier Annual Sporting Event

It is sport's premier event, the spectacle of spectacles, the focus of a major portion of the earth's population for one Sunday each January. It is the Super Bowl, and one game just doesn't get any bigger.

More than 750 million people in 60 countries from Thailand to Iceland now tune in to what has become a global event. In the United States, most normal life comes to a stand still on Super Sunday. Crime subsides, streets empty, and an entire nation watches.

As football's ultimate showcase, the Super Bowl is where greatness comes to prove itself, where today's best test their mettle against each other and against the legends of the past. It's a stage for drama: Joe Montana coolly leading his 49ers down the field in their comeback win against Cincinnati. It's a site for comedy: Garo Yepremian watching the football squirt from his grasp and turn into a Washington touchdown. It's a spot for balletic grace: Lynn Swann leaping, diving and stretching all at once to snare a pass against Dallas. It's a place for vindication: Jim Plunkett rising from near-oblivion to quarterback the Raiders past Philadelphia. And there's even room for sentiment: Jim Burt trading kisses with his young son; Art Rooney, Sr., receiving the game ball from his Pittsburgh Steelers after their first-ever championship; Jerry Kramer carrying Vince Lombardi off the field following the final triumph of a legendary dynasty.

On January 27, 1991, in the frightening shadow of war, America took time out and watched as two teams wearing red, white, and blue played perhaps the most exciting Super Bowl ever, on the twenty-fifth anniversary of the game's debut. While the Tampa Stadium crowd waved miniature Star Spangled Banners, the Buffalo Bills and New York Giants staged a remarkable football clinic that lasted four quarters. Only when Buffalo's 47-yard field-goal attempt sailed wide right with four seconds left in the game was the Giants' 20-19 victory secured.

It is games such as Super Bowl XXV that make the NFL an increasingly integral part of our cultural heritage. If asked, almost all fans in America could tell you where they were that January evening, whether it was out with friends, at home, or on the 20-yard line. In fact, many could tell you where they will be for the next Super Bowl as well.

—THE NFL AND YOU, 1992–1993

commodities to be used and discarded when their utility no longer increases the bottom line. Claims regarding the physical fitness associated with sports enhance the myths constructed around athletes' achievements, but they mask the sobering statistics on player injuries, drug and alcohol abuse, and early mortality, football's unsung legacies. Injuries plague NFL players' brief careers and adversely affect their post-NFL lives. In preparation for its Super Bowl coverage, at the end of the 1991 football season, the St. Paul *Pioneer Press* conducted a poll of NFL players active from the 1960s through the 1980s.[26] Their reports of football-related injuries only begin to suggest the violent nature of activity on the gridiron.

Of the one hundred retired players polled, 82 percent experienced ailments they link to their NFL careers. Players reported knee injuries most frequently, but in addition, many listed problems with shoulders, backs, lower arms, and hands. Sixty-five percent of the players surveyed reported arthritis symptoms, the consequence of repeated injuries and surgeries designed to extend players' careers, which span less than four years, on average. And injuries force many players into retirement before they can earn their pensions. Statistics hammer out the hazards of professional football: 67 percent experienced a major injury causing them to miss three or more consecutive games, while 34 percent experienced two or more such injuries; 56 percent of those surveyed said they left pro football because of injuries compromising their ability to play; 52 percent said that injuries have limited their ability to do physical work, and 48 percent said that their injuries limit their participation in recreational sports; 21 percent underwent surgery for football-related injuries since retirement; and 65 percent believe that pro players have a shorter life expectancy than the general population—actuarial studies support their fears. The sport has become more dangerous over time: between 1960 and 1980 the injury rate increased 77 percent.

Why is football a game that maims? Since its emergence in the 1800s American football has been noted for its violence, but only recently have studies enumerated the risks. Some suggest that steroid use, officially prohibited by the league in 1989, has produced bigger, faster players whose collisions do more damage. Others cite the adverse affects of playing on artificial turf. Yet others attribute the rise in football injuries to television's need for an exciting, dramatic show, in order to keep viewers riveted and guarantee robust advertising sales. As player activists have begun to expose the hazards and stresses associated with professional football, a useful wedge in salary negotiations, the NFL has commissioned its own studies of player injuries. They have examined such factors as artificial turf, and, not surprisingly, the results they cite differ from the *Pioneer Press* study, contradicting players' reports of their own health histories. NFL-commissioned data serve the interests of owners at the bargaining table.

Regardless of statistics, players' own experiences make the facts clear. By the time they get to the NFL, players already know they face risks. They know their coaches will expect them to play despite injury, to overcome pain, and to suppress knowledge of the consequences likely to result from the physical punishment their bodies endure. These lessons have been taught in high school and college. And despite this knowledge, athletes vie for the chance to put their bodies on the line for the NFL: 83 percent of those surveyed said "the benefits of playing outweighed the risk of physical problems later on." Many players willingly endure pain. According to one player interviewed for the *Pioneer Press*

study, "The more I was hurt, the more I enjoyed the game. It was a red badge of courage. It made me even more competitive. There is something in the male ego that says, 'Not only am I playing, but I'm playing hurt, so I must be pretty good.'" The same refrain reappears in player memoirs. The league has no problem finding men to fill out team rosters, men who are willing to bulk themselves up for gladiatorial combat, to spend their health and vitality in exchange for the thrill of the contest and the celebrity it can bestow. Players and owners both know there are plenty of athletes who are hungry for a chance to enter the league, and with this added stress, players wring out every possible minute on the field, until younger, more vital players replace them.

Studies of racial segregation and "positional stacking" deflate claims for the democracy of sport, another staple element of the creed. The percentage of African Americans playing football rose from 6 percent in 1956 to 61 in 1991; nevertheless, sports sociologists demonstrate the persistence of barriers to integration on the field. Following Frederick Winslow Taylor, Walter Camp urged that the division of labor among players reflects their endowments of brain or brawn. Data suggest that college coaches assign positions according to the racial stereotypes they hold; white players do the brain work, while African-Americans use their physical prowess.[27] Studies also show that professional football coaches assign African-American players to primarily noncentral positions in both offensive and defensive formations.[28] So while the number of African Americans playing football has increased, coaches ghettoize them on the field, limiting the nature of their participation.

Positional segregation has negative implications. White players are able to gain more experience on the field, so a higher percentage may qualify for pension benefits and higher average amounts of severance pay.[29] Positional segregation reinforces players' tendencies to self-segregate, preventing the establishment of informal networks and ties that facilitate career mobility.[30] The NFL's record on the sidelines demonstrates the lack of mobility characteristic throughout the organization. According to data compiled in 1991 by the Center for the Study of Sport in Society at Northeastern University, while African-Americans constituted 61 percent of all NFL players, just 6 percent were employed in the front office. Ninety-seven percent of NFL coaches are white. Little opportunity for mobility exists within the NFL for minority players, and at the end of their playing careers they can expect to be cut loose from the organization. Retired players without disabling injuries gravitate toward jobs commensurate with the level of education they attained prior to their football careers,[31] and graduation rates among football players have declined sharply, especially among African-American athletes. In 1982, only 20 percent of African-American players had earned a college degree, compared to 40 percent of white players. Figures from 1985 show that NFL graduation rates were 10 to 30 percent below national averages, but 20 to 40 percent below among African Americans. [32]

The notion that professional sports provide a ladder for social mobility, especially for minorities, has entered the realm of popular wisdom, but the figures contradict such claims. According to 1987 data, odds predict only one in thirty-five hundred aspiring African-American athletes actually go on to careers in professional leagues.[33] Once they land a coveted spot on the roster, minority players find themselves limited by organizational racism. When their football careers end, for all but a few exceptional athletes the future hinges on the education they brought with them to the league. Despite

athletic scholarships, deteriorating college graduation rates and watered-down degree programs fail to prepare young men for life after the NFL. Exploited by their colleges, denied the education necessary for future job prospects, after four years most NFL players find their careers over, with no golden parachute awaiting their early retirements. The brilliant careers and financial security achieved by the few have come to stand for the lives of all professional athletes, creating an envious public, unsympathetic to players' calls for more equitable salary structures or safer job conditions. The myths enveloping "superstar" athletes benefit team owners by drawing crowds and quelling labor unrest among the players who work the gridiron.

The sports creed first began to emerge in the late nineteenth century as an instrument used by social reformers promoting amateur athletics. The creed has now been pressed into service in support of professional sports. The seemingly benign notions associated with participation in athletics disintegrate in the professional arena. Contemporary sports, a commodified entertainment product, depends as much upon leagues of spectators as upon players, spectators for whom athletics have become events to observe, not activities to experience. The sports creed offers a remote, unvalidated ideal that the NFL exploits to sell its wares and mask its casualties. As they reap their financial rewards, the NFL and its partners—the media and the corporate sponsors of professional football—simultaneously activate the commonsense ideals that perpetuate their power: competition yields superior performance; with the guidance of their superiors, expert, scientifically informed managers, workers can cooperatively deploy their competitive instincts (their aggression and their strength) to vanquish opponents, the ultimate goal of engagement; victory depends upon combatants' recognition of their appropriate roles, assigned by managers—white men possess superior leadership abilities and intellect, men of color possess superior brute strength, women belong outside of the competitive arena altogether. These multiple intertwined messages, cloaked in athletic heroism and the innocent pleasure of sport, flood into living rooms around the world on Super Bowl Sunday, the NFL's consummate ritual. The hegemony of football is so complete that even its most informed critics cannot quite renounce it. As Michael Real writes, "While the critics may overstate their case, viewing the Super Bowl can be seen as a highly questionable symbolic ritual and an unflattering revelation of inner characteristics of mass-mediated culture in North America. Nevertheless, to be honest, for many of us it still may be a most enjoyable activity."[34]

NOTES

[1] Michael Real, "The Super Bowl: Mythic Spectacle," p. 186, in *Television: The Critical View*, Horace Newcomb, ed., Oxford University Press, 2nd edition, 1979, pp. 170-203.

[2] Michael Oriard, *Reading Football*, University of North Carolina Press, 1993, p. 282.

[3] See Harry Edwards, *Sociology of Sport*, Dorsey Press, 1973; Allen Guttman, *Games and Empires: Modern Sports and Cultural Imperialism*, Columbia University Press, 1994; George H. Sage, *Power and Ideology in American Sport*, Human Kinetics Books, 1990; and *Media, Sports, and Society*, Lawrence A. Wenner, ed., Sage Publications, 1989.

[4] Michael Real, op. cit., p. 202.

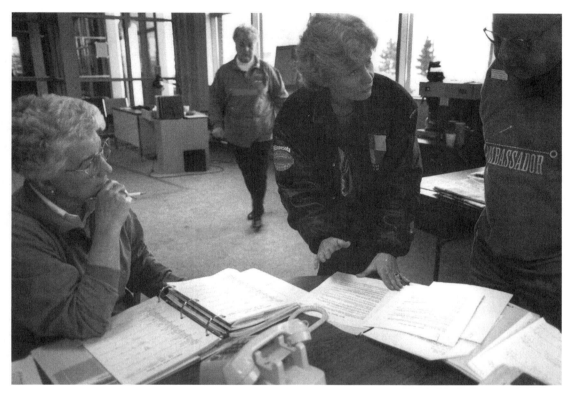

Volunteer ambassadors staffing a satellite phone bank receive last-minute instructions from a member of the task force in the early morning of Super Bowl Sunday.

Volunteer Information

<u>Hotel Ambassador Tables: Job Responsibilities</u>
There are several goals to follow to meet the varying needs and inquiries of these visitors.

1) Be polite. Smile. Ask them if they're having a good time.
2) Be helpful. Remember, you represent Minnesota to the visitor. Whether you give them the answer they want or not, make them feel as though you've done the best job you can at assisting them. This usually means looking in several pieces of literature, flipping through the Reference Manual, perhaps even calling the Task Force phone bank to see if they have the answer...

VOLUNTEER HANDBOOK: MINNESOTA SUPER BOWL XXVI TASK FORCE

3) Read all the materials that you have been given, thoroughly, at least once. Then you will have a general idea of the kinds of answers you will be able to give.
4) Only answer the questions within these materials. If someone asks you about the economic impact of the Super Bowl on Minnesota, explain that you are not exactly sure and give them the number of the Super Bowl Task Force Media Relations contact.

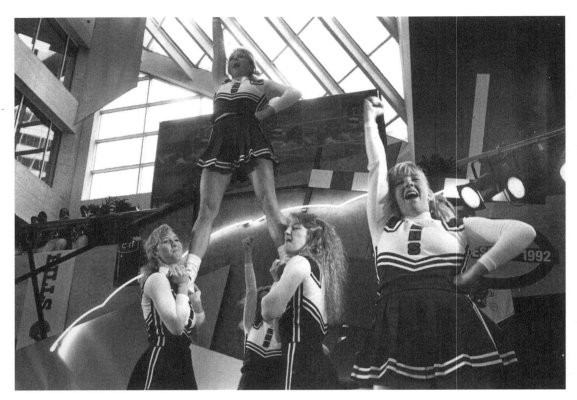

The task force recruited local high schools to participate in the community effort to entertain visitors. For the moment, the young cheerleaders filled the shoes of their big sisters and roused the men gathered at the corporate office plaza. Ambassadors roamed the skyways, distributing copies of the Minnesota Super Bowl XXVI Playbook listing local events.

Kickoff was scheduled for 5 p.m., accommodating the West Coast television audience, and the task force exploited its final opportunity to showcase the city's hot-party atmosphere. By early afternoon ticket holders streamed out of their hotels and into the streets heading for pep rallies the task force had scheduled. Appropriately enough, the atria of two corporate office towers were designated team headquarters: the IDS Crystal Court and the Pillsbury Plaza. The task force actively set about manufacturing team spirit: "Super Bowl-goers will be fired up by Twin Cities area high-school marching bands, dance lines and cheerleaders." In search of authenticity, the planners sought to create a "hometown flavor" by inviting radio personalities and "dignitaries" from Buffalo and Washington, D.C., "to help excite the crowd." Fans obliged and turned out dressed in their Super Sunday best, a mix of costumes including furs, beads, chicken feathers, hog snouts, and buffalo horns. They wore team jerseys and shaved team symbols into haircuts sculpted on-site. At the Pillsbury Plaza, Buffalo's mayor delivered a rousing speech, while ritually garbed Redskins fans performed Hollywood-style war dances at the Crystal Court, harassing Bills supporters who brazenly entered enemy territory.

The Redskins offensive line inspired its own cheerleading squad, the Hogettes, who dress as washerwomen-in-snouts. With the enthusiastic approval of fellow fans, a Hogette displays his strength for the camera.

No Underdogs Found in NFL's Big Tent

In the Super Bowl, even the gatecrashers arrive in limousines. Chief executive officers drink vintage wine in the leather-lined sanctuaries of their stretches while their corporate vice presidents work the streets looking for tickets.

No, doctor, there are no underdogs at the Super Bowl these days. Everybody was a winner here, long before Washington and Buffalo finally—bloody finally—went out and played the Super Bowl yesterday evening.

NEW YORK TIMES By definition all the beefy, beery, unshaven gents lurching around the lobby of the Hyatt the last few days were winners, having arrived at the psychological center of American sports. These were all yuppies in grubby disguise. Anybody who couldn't pass a computerized credit check was detoured outside a 20-mile safety zone.

For Some It Was VII Hours of Hoopla—Game Takes a Backseat to the Show

How much did it cost for two people to do the Super Bowl, from parking your car outside the restricted zone to tickets to souvenirs to your refreshments? Well, here goes. Let's assume the tickets went for face value—$300 a pair.

You could park for $15 in one of the lots on Fifth Avenue. Add $20 for two programs, $25 for the least expensive sweatshirt and $15 for the least expensive T-shirt. (You could spend up to $65 for the fanciest sweats and $18 for a T.) The cheapest cap was $15, a pennant was $4. *MINNEAPOLIS STAR TRIBUNE*

Like most people you arrived well before game time, right? Two large beers were $7.50 and two regular Cokes were $4. Two bratwurst cost $5.50 and that late game snack included a pretzel ($1.75) and an order of nachos ($2.50). Your total: $415.25.

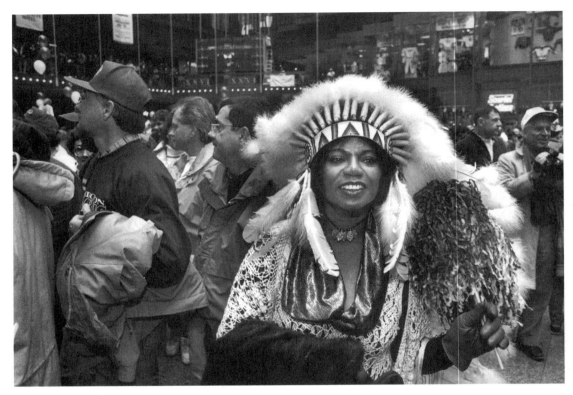

Gloria Gogolski provides ready-made material for photographers in search of arresting images.

The noise was deafening. High school marching bands, cheerleaders, speeches, spontaneous shouts, and war cries. Then from the women's restroom came the sound of applause. I approached to investigate. An appreciative throng ringed a woman as she emerged from the bathroom. What exceptional feat had she performed? Gloria Gogolski wore a white ankle-length Indian headdress and white-fringed macramé weskit. For warmth she wrapped in skins—a fur coat. Knowing that she had disrobed to access the toilet, the crowd saluted her team spirit with their resounding applause. What motivated this woman to render herself a spectacle? Did she crave attention? Was she claiming her fifteen minutes of fame? I wondered what Gogolski thought about AIM's protest against racism in sports. As a person of color, had she concluded that her own success undermined the merit of their argument? The noise and festivity quelled such provocative musings. Wherever she went Gogolski drew the attention of spectators, and her elaborate costume seduced the lens, cajoling, "Take my picture." I too felt obliged to get my shot of a Superfan, especially one so elaborately arrayed. On Monday, when I reviewed the local media's coverage of the day's events I found Gogolski in every newspaper. Did this signal my own failure to depart from the pack? Had I succumbed to the same enticements as had the press? Does the image perpetuate the intolerance I've attempted to expose and critique?

Despite warnings by local police that ticket scalpers would be arrested, fans circled the Metrodome, holding aloft signs indicating the number of tickets they hoped to buy. Scalpers discreetly went about their business, leaving satisfied fans in their wake.

Luck Ran Out For Optimistic But Ticketless Fans

They came so far and got so close.

But as Buffalo kicked off to start Super Bowl XXVI, about a hundred people stood shivering outside the Metrodome, watching the game on the big screen TV that was set up across the street. Many still were holding signs that said: "I need tickets."

Those stories about scalpers dropping their prices from $400 and $500 before the game to face value or less by kick-off weren't even close this year. By game time, many were still asking $200 to $400, with a few exceptions. And there were many more buyers than sellers.

"It's pretty bad, watching a football game in the street," said Danny Gianeli, who came from New York expecting to get a ticket. "This time last year in Tampa, you get a ticket for $30. I'm pretty surprised."

Eric and Margarita Klanderud came all the way from Guatemala, where the Super Bowl is the biggest game of the year. They planned ahead, bought plane tickets a month ago and found a room at Motel 6 in Roseville a week ago. But they couldn't find two tickets for under $500, which was $100 over their limit.

MINNEAPOLIS
STAR TRIBUNE

They weren't complaining though. "We'll happily ask where's the Hyatt, or another hotel and we'll go there and have a drink and watch the game," said Eric Klanderud, a petroleum engineer from Guatemala City. "We're sportsmen. We teach our kids, if you play tennis don't throw the racquet. Don't ruin the spirit of the sport."

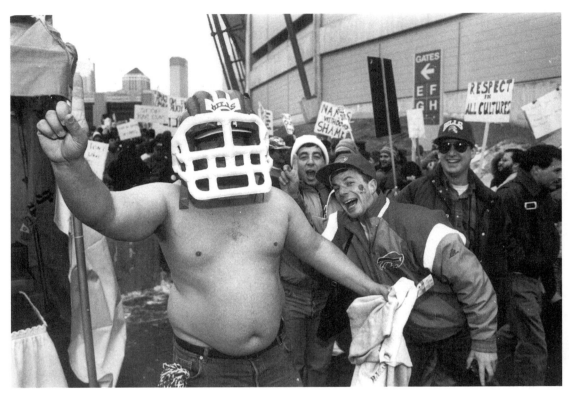

Vikings cheerleaders stream into the stands, chanting and shaking their pom-poms to energize the crowd. Primed with team spirit and beer, Buffalo fans gather outside the Metrodome and prove their mettle in front of the omnipresent camera-eye.

When the pep rallies ended at 2:15, ticket holders embarked on their journey to the Metrodome, roused and ready for the game. Some navigated on foot through the maze of skyways, while others traversed the short distance via limousine. The long-awaited moment of visibility had finally arrived. Minneapolis and the Hubert H. Humphrey Metrodome appeared on television screens around the world. People with tickets and people with causes converged on the site to exploit the presence of the media, to see and be seen, and the assembled throng evoked the cacophony of a carnival sideshow. A man dressed as a camel positioned himself behind a reporter doing a stand-up, and held his sign in front of the camera: "I'm killing your kids." A unicyclist deftly maneuvered through the moving crowd wearing a sign on his back that read, "I need international publicity." Soft drinks made a return appearance—high school students hired to dress as Pepsi and Coke cans competed for the attention of passersby. Demonstrating their machismo, rotund men stood bare-chested, drinking beer while turning red and goose-pimply in the subfreezing breeze. Countering the partial nakedness of these avid fans, more restrained ticket holders prepared for the camera and the cold swathed in full-length fur. Capitalizing on the confluence of cash, vendors hawked souvenirs of all kinds, while ticket scalpers furtively surveyed the police-peppered terrain before conducting their illegal transactions. As I moved through the crowd trying to capture the feeling of the pregame rite I encountered fans who, like me, attempted to preserve the festive moment with their camcorders and cameras. The pictures made outside the Dome on Super Sunday would, no doubt, spin off many future Super Bowl stories.

Ticket holders pose for a snapshot before entering the Metrodome, several hours before game time.

Live music, five big screens and a dozen carnival game booths were on the bill at the St. Paul Civic Center in the Sears Super Sunday Big Game Party, an event touted as the common folk's alternative to the Metrodome.

But the common folk went elsewhere, particularly to the Winter Carnival Ice Palace.

"You missed the crowd—all 15 of them," said one woman, re-stacking a mountain of unsold Super Bowl sweatshirts, T-shirts and caps at the Civic Center. "It's a disaster."

About 500 people were scattered throughout the arena through the game's first half. Security personnel said the crowd had been bigger earlier in the day for music by Johnny Holm and Nick and the Nice Guys.

But Mike Fox, 22, of St. Paul, found the event to his liking. He and his girlfriend, Jennifer Kivi, 20, of Park Rapids, were nearly

MINNEAPOLIS
STAR TRIBUNE

alone in a section of seats directly in front of a video screen suspended from the arena ceiling.

"This TV is huge," Fox said. "It's better than the one in my apartment."

A block away, Rice Park was ringed with people waiting in slow-moving lines to board shuttle buses that would take them to the ice palace on Harriet Island. Marlene Hodges and John McAlpine, both of St. Paul, figured they'd find no waiting while the Super Bowl was being played and they'd be back home in time to watch the second half.

"We've heard a lot of other people say the same thing," said McAlpine, nursing a hot chocolate as he shuffled along the fourth street side of Rice Park. He and Hodges had spent 20 minutes waiting at the Capitol for a ride to Rice Park, where they expected to wait 35 minutes for a ride to the palace. But they weren't regretting their choice.

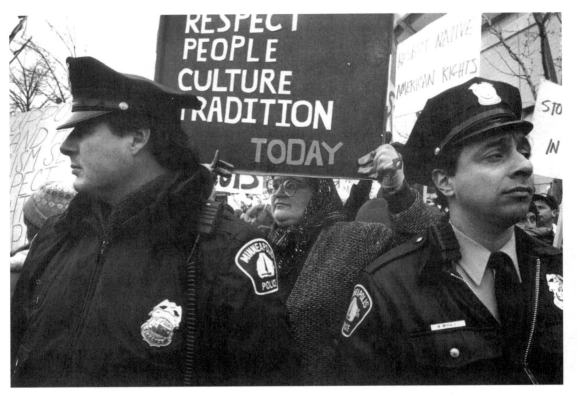

Protesters allied with the American Indian Movement exploited the presence of cameras and mounted their own media spectacle.

As anticipated, American Indian Movement protesters ringed the stadium they likened to a covered wagon, and boisterously chanted slogans that gave voice to their cause. They too had come to be seen and, as intended, their placards and banners caught the attention of journalists and visitors alike. The protest appeared on television screens, in newspapers, and in souvenir snapshots, a discordant moment framed within the context of corporate America's own celebration. The Minneapolis police turned out in numbers that rivaled the protesters' and they watched over the peaceful demonstration, ensuring the safety and the well-being of our guests. Fans like Gloria Gogolski, in their chicken feathers and war paint, advanced through the protest with impunity, passing the people they parodied with little more than a sideways glance. I wondered what Gogolski was thinking—if she felt anything at all—as she walked past Clyde Bellecourt, microphone in hand, politely addressing the crowd. Had Gogolski ever before encountered a Native-American person? Had she ventured from the hotel to see the Minneapolis ghetto where "redskins" live? Had the Redskins' appearance in the Super Bowl enhanced the lives of the Native American community and instilled in them the same pride felt by Redskins owner Jack Kent Cooke? Had the benefits to the minority community heralded by the NFL ever materialized? The presence of the media extended AIM a platform for protest, and they organized a peaceful, effective campaign. But the riotous jumble of sights and sounds overpowered their voices, and the celebration absorbed dissent. It was time to move on to the next arena, the stadium. I headed for the designated media entrance and dragged my bulging camera bag over the turnstile, leaving the carnival behind. With a final backward glance I saw a man dragging a monumental cross, warning of the world's imminent end. I hoped to get out of the Dome before the Armageddon he foretold.

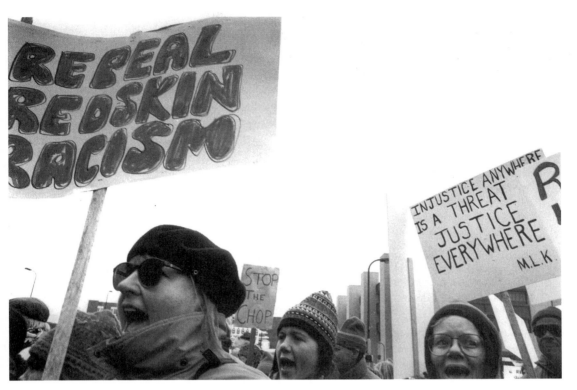

The media attended to the sights provided by protesters and fashioned them into photos and footage. Most ticket holders employed a different strategy and, instead, ignored the picketers, walking past with practiced oblivion.

Redskins flap not Super Important

Clyde Bellecourt, national director of the American Indian Movement, is worried—well, more than worried; incensed—about Washington being named the Redskins. "How would you like it," he asked, "if your hometown team was named the blackskins?"

A fair question. But this Indian-Warrior-Redskin-Braves situation is irreconcilable. Universities may change their names, because political correctness has become a campus obsession. Pro teams, however, are judged only by winning and losing.

SAN FRANCISCO EXAMINER

The World Series involved the Atlanta Braves and the tomahawk chop. An ethnic slur? If you choose to interpret it that way. But the sports fan isn't thinking of Native Americans. He's thinking of whether Mark Rypien can hit Gary Clark deep. Believe me.

I sympathize with Clyde Bellecourt, but he gives people too much credit. To them the names are generic, not specific. The way our educational system works these days, I doubt anybody under 30 even knows Redskins is a synonym for Indians.

You know what they care about in Washington? How to get tickets to the games. That goes for congressmen as well as janitors.

There are 55,000 season ticket-holders to Redskins games, but only 7,000 received Super Bowl tickets through a complex lottery. Since there were 55,000 requests, at $150 a ticket sent in advance, there is $7.2 million still accumulating interest in the Washington accounts until refunds are made Jan. 31. Redskins? They ought to nickname the club Outlaws.

For a long while, Washington should have been called the "whiteskins." The city, after all, is in the South, and the team's original owner, George Preston Marshall, had racial myopia. The blacks around the District of Columbia used to joke seriously that to Marshall NAACP meant Never at Anytime Any Colored Players.

AIM
American Indian Movement

Mr. Paul Tagliabue, Commissioner of Football
410 Park Avenue
New York, N.Y. 10022

Dear Mr. Paul Tagliabue,

The American Indian Movement is the foremost advocacy organization representing and defending the spiritual, cultural, political and treaty rights of the Indigenous (Indian) peoples in all of North, Central and South America.
 The efforts by Indian people to cleanse organized sports, both within major league baseball, the national football league and hockey, as well as high school and university athletic programs has been ongoing for years. Our struggle was not determined on which team wins a pennant, or of that matter who should play in a world series or a super bowl. However, as the Atlanta baseball team was able to come from behind as did the Minnesota Twins, it gave us the opportunity to put this issue of racism in sports before the national and international arena of public opinion in a way that Indian people are clearly the winners. We have received hundreds of calls and letters both national and international in support of our efforts to change these demeaning names (i.e. Washington Redskins) mascots, symbols and stereotyping by sports teams and athletic programs.
 The use of Indian names, logos, mascots, regalia and themes in sports is demeaning and degrading to our culture and spiritual customs and traditions. The fact that various athletic programs, both professional baseball, football all and hockey, as well as amateur university, colleges and high school programs, use of Indian names causes the spectators to act in a way that trivializes our culture and spiritual way of life and belittles us as a people.
 The Head Dress of Eagle Feathers was and continues to be reserved four our most revered and respected Chiefs and Spiritual Leaders. The feathers are earned through a lifetime of service to the people. Markings on the face are a part of our most sacred ceremonies, such a s a young man or women entering adulthood, a wedding ceremony and that time in life when one is taken back into the bosom of Mother Earth and enters into the spirit world.
 The drum is said to be the heartbeat of our nations of people. Our songs are either prayer songs or honor songs. All of these traditions continue to be practiced after thousands of years. As such these traditions and ceremonies are deeply respected and revered by our Indian peoples.
 The tomahawk was first used as a tool as one would use a hammer. Of course it was also used a s a defensive weapon when we wee forced to defend our territories and people against the encroachment of America's first "boat people."
 The drum beating, cheap Hollywood chants, chicken feathers, war paint and the tomahawk chop by sports fans cheapens and is an insult t our true culture. Furthermore, it is an embarrassment to most Indian people, moreover we find that it is likewise embarrassing to the American people in general.[. . .]

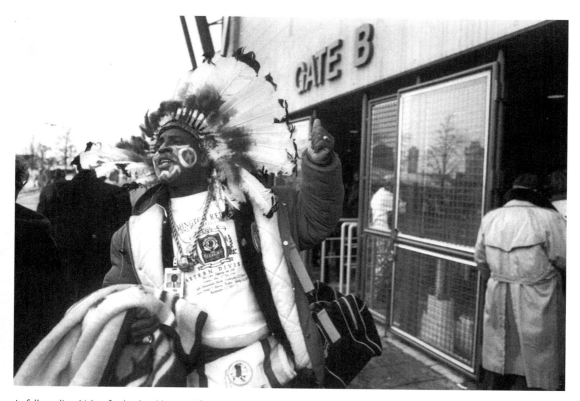

In full regalia, chicken-feather headdress and face paint, a Redskins fan beckons to gather the tribe and enter the stadium.

Redskin n. (1699): American Indian, usu. taken to be offensive.

WEBSTER'S NINTH NEW COLLEGIATE DICTIONARY

Redskin n. *Slang (often disparaging and offensive).* a North American Indian.

THE RANDOM HOUSE DICTIONARY OF THE ENGLISH LANGUAGE SECOND EDITION

```
"Hail to the Redskins"
Hail to the Redskins
Hail Victory!
Braves on the warpath
Fight for the old D.C.
Scalp'em, swamp'um, we will
take'um, weep'um, touchdown,
we want heap more,
Right on, fight on, 'til you have won,
Sons of Wash-ing-ton.
```

An FBI unit remained on-site for the duration of the game, ready to repel any threat to the safety of the assembled corporate leadership.

My roving press pass meant that I had permission to photograph anywhere off the field. I kept that in mind when I discovered the FBI. I had begun my tour of the Metrodome, when I encountered a long corridor lined with cases holding band instruments. At its apparent end I spied a drawn curtain. "What's beyond the curtain?" I asked a man whose task appeared to be safeguarding the instruments. "Oh, nothing," came his bored reply. "I can't imagine a curtain hiding nothing in particular," I thought as I approached the end of the corridor. Drawing the curtain aside I came face-to-face with a troupe of men (and a woman or two) uniformed in camouflage fatigues. Like everyone else they were waiting for the game to begin. The pregame show flickered on several TV screens, and there were snacks and a cooler filled with soft drinks. They seemed slightly edgy as I moved among them, making small talk and pictures. As I knelt to frame a shot I saw a large black shield propped against the wall, emblazoned with the letters F B I. The longer I remained the more uncomfortable they seemed, while I became increasingly pleased with my discovery. Extraordinary precautions had been taken in order to protect the well-being of the corporate elite; even so, I hadn't expected to discover this security detail. I finished a roll of film, and as I reloaded an agent approached, suggesting that perhaps I had shot enough. I had other discoveries to make, so I thanked him and resumed my trek. As I emerged from the curtained cul-de-sac I thought about their uniforms. Camouflage. I would make a different choice if I wanted to blend in.

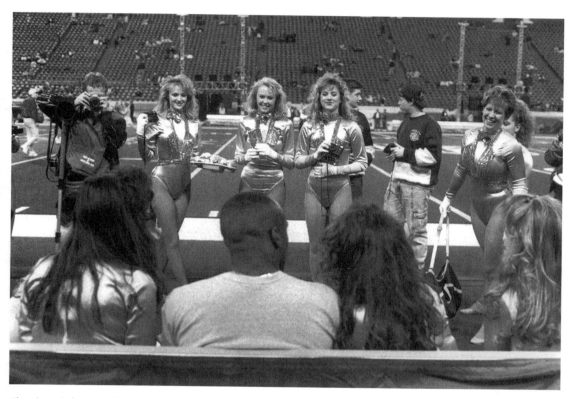

Three hours before game time, women waiting to appear in the opening ceremonies collected souvenir snapshots. Much seen and little heard, reporters chose not to write any stories about members of the dance lines or the cheerleaders—the decorative players on the field.

Buffalo Jills cheerleaders ready themselves for their imminent appearance on the sidelines, suiting up and rehearsing their moves.

Winding through another cinder-block corridor I saw a door marked "Jills." After a moment or two I deciphered its meaning—cheerleaders, the Buffalo Jills. I saw someone entering and asked if I might be permitted to shoot the squad as they prepared. I was glad to be a girl. Their coach met me in the corridor and said I was welcome to come in, so long as I didn't go into the shower area or take any compromising photos. I gave my word and entered the cheerleaders' locker room. The women prepared themselves for the spotlight, fixing their hair and makeup, perfecting the fit of their uniforms and attaching new trim. A monitor perched atop the lockers showed videotapes of the season's games to set the mood. Women snaked themselves into leggings, glancing up at the screen from time to time, emitting enthusiastic shouts in response to successful plays they had seen before. A small group carved out a space amid the gear and began practicing their choreography and perfecting their moves. One woman, the most intense and serious among them, led the rest as they mimicked the provocative movements she performed. Shoulders back, head cocked, hand to waist, knee bent, toes pointed. Quick head turns sent long hair flying through the air. They must have rehearsed these poses in front of many mirrors, each woman assessing her own allure and camera-worthiness. Unlike the FBI, they seemed completely at ease as I carefully picked my way through the cluttered space and photographed them at their tasks. After all, they had traveled to the Metrodome to be seen. They engaged me in friendly conversation; I was just another girl working the Super Bowl. I could have lingered, but other sights awaited the probe of my lens. I left the effervescent excitement of the Jills locker room to prowl the cold concrete maze outside.

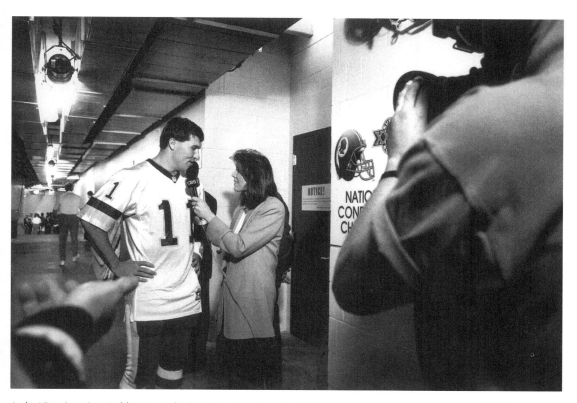

Lesley Visser interviews Redskins quarterback Mark Rypien outside the Washington locker room, three hours prior to kickoff.

A joke or not, it wasn't funny for sportscaster and she left fast

A mortified Lesley Visser found herself in Solid Gold last week and quickly propelled herself right back outta there. An equally mortified male colleague of hers—one Buddy Martin, a go-fer assigned to Terry Bradshaw—called your gossip columnist to explain, "It was basically a trick on Lesley." Visser and Martin clearly hadn't synchronized their tales. "On my life it wasn't a trick," Visser told us. "It wasn't funny. It was a total mis—understanding. We had gotten a ride back from the restaurant and they (who?) said 'Let's stop in this bar.' We walked in. It's definitely not my

MINNEAPOLIS
STAR TRIBUNE

scene and I left." Another patron of the bar confirms that the female member of the CBS sports team left pronto saying something like Get me out of here! She reportedly left behind her "NFL Today" cohorts Bradshaw and Greg Gumbel and a third less recognizable fella. Our patron-spy would almost swear that Gumbel and Bradshaw dropped at least $100 to have women personally shake their breasts in their faces, a ritual we call "lap dancing." Therein lies a better tale than her briefest of Solid Gold appearances, Visser sputtered. Indeed. We left messages for the guys at their hotel, at Solid Gold, at Deja Vu and at Denials R Us. They have yet to ring us back. We remain patient.

At one time, women, like black Americans, did not have the same rights as everyone else. Times have changed. Women now fight in wars. They battle crime everyday in police forces throughot the nation. They work as trainers in college athletic departments.

Women have earned the right to perform all kinds of jobs once restricted to men, including football writer. Please respect that right.

NFL MEDIA RELATIONS PLAYBOOK

CBS news anchor Dan Rather obliges a police officer with an autograph after coming through the turnstile.

There were supposed to be celebrities aplenty, and I figured I should surface from my underground patrol to see who came through the turnstiles. Photographing others getting revved up for the game gave me an adrenaline burst and I moved quickly from place to place stalking subjects. This must be what a paparazzo feels like. I cruised the gates looking for people whose purpose is to appear before the camera, so that I could make my own photographs of them. Is "suitability for media consumption" the contemporary definition of celebrity? I remained on celebrity-alert as I photographed the incoming rush, but encountered only one famous person, CBS anchor Dan Rather. Where were the stars attending the Super Bowl? Down below I had discovered a loading dock admitting only limousines, and I waited for a glimpse of someone important. I recognized no one among the passengers whisked off to their seats by efficient attendants. With such uncertain payoff I decided not to linger. As I combed the corridors I began wondering about the nature of celebrity and other markers of social status. Had I observed celebrities exiting their limos, or were they VIPs? Are media celebrities also VIPs? Are VIPs celebs? Did people of importance have an aura that I would recognize? I saw Walter Mondale in the distance, flanked by a body guard, surrounded by autograph seekers. Perhaps celebrity's aura is an entourage.

In an office beneath the stands filling with Super Bowl spectators, a Metrodome employee observes the multiple monitors that facilitate surveillance.

1991 NFL National Corporate Sponsor List

National Sponsors
American Airlines
American Express TRS Co., Inc.
Anheuser-Busch, Inc.
Arpin Van Lines
Avis Rent-a-Car System, Inc.
Brunswick Corp.
Cadillac Motor Car Division
Canon Camera
Chattem Consumer Products
Citibank
Coca-Cola
DHL Worldwide Service
Digital Equipment Corp.
Millsport
Hershey Chocolate
Holiday Inns
Kimberly-Clark
Kiwi Brands, Inc.
Miller Brewing Company
Mobil Oil Corp.
Owens-Corning Fiberglas
Proctor & Gamble

Quaker Oats Company/Gatorade
Schering Plough
Seagram's Wine Cooler
Sealy, Incorporated
Slim Fast Foods
Sony Corporation
Tasco
TCBY
Toshiba America
Zenith Data Systems

Tailgate Clients
A. H. Robins
Alpo Pet Foods
American Home Foods
Beatrice/Hunt-Wesson
Campbell Soup Company
Chesebrough Ponds, USA
The Clorox Company
First Brands Corp.
Fuji Photo Film
General Mills
James River Corporation
Kiwi Brands

Kraft General Foods
Lever Brothers Household Div.
Nabisco Biscuit Company
Ocean Spray Cranberries, Inc.
Ore-Ida Foods
Oscar Mayer Foods Corp.
Pillsbury Company
Quaker Oats Co.
Ralston Purina
Riviana Foods
Whitehall Laboratories

Home Team Clients
Ac Delco
Castrol Oil
Cooper Tools
First Brands
General Electric
The Glidden Company
Owens Corning Fiberglas

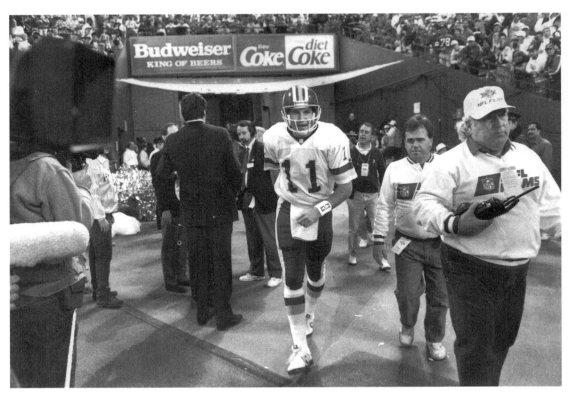

Redskins quarterback Mark Rypien emerges from the locker room to warm up before the game. Although he would soon draw everyone's attention, few fans took note of his pre-contest warm-up.

When I checked in at the photographers' area I received a photo fanny pack and a pocket knife, courtesy of Canon Camera, the official camera of the Super Bowl. These were dispensed along with my standard-issue photographers' vest. The field was divided into four quadrants, and our vests were color coded according to assigned locations. We were warned that security guards would patrol the sidelines corraling photographers according to their colors. I left my bright red Canon-logo fanny pack behind, determined to avoid becoming a walking promotional vehicle. Photographers were packed in like sardines along the sidelines, and they busied themselves settling into their positions, like soldiers in the trenches. A face stood out amidst the crowd, a photojournalist friend from the St. Paul Pioneer Press. He crouched in his slot on the 20-yard line supporting the weight of a 400 mm lens. The newspaper sent five photographers and they were scattered around the sidelines, maintaining contact by radio. My friend's position measured about two feet by three, and the photographers' lenses forming a roof above his head foretold a long uncomfortable evening. But he had a reliable script to work with, good field position, and a fast, long lens, assuring a him a successful shoot. I had freedom to move, but no map telling me where to go. I said goodbye, and as other photographers secured their territory I walked the length of my quadrant, coming to grips with the fact that for the next several hours I would be the odd man out among the troops of photographers. Like me, other players psyched themselves for the upcoming event. Performers appearing in the opening ceremonies paced while they waited for their turn to appear "onstage." Team members surfaced from the locker rooms to stretch, or sprint, expelling some of their pent-up tension before the contest. Fans streamed into the stadium and the clamor grew as the crowd awaited the spectacle.

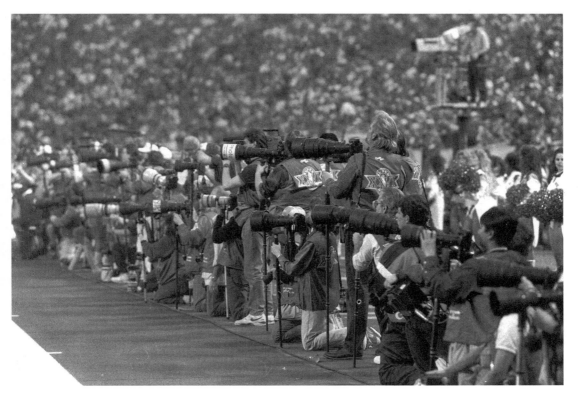

Press photographers formed a human wall along the sidelines. In synchronized waves, their motions tracked the game. The staccato chorus of motor-driven shutters foretold a multitude of near-identical images destined for publications around the world.

American football — Morituri te salutamus

Compassionate, user-friendly, politically correct Minneapolis seems an odd venue for the athletic and corporate machismo of the Super Bowl on January 26th. Super Bowl XXVI (the Roman numerals evoke gladiators) is designed to draw, as usual, waves of company bosses—the kind of people who equate winning at football with wiping out competitors—to spend great sums while watching the vast meat of the Buffalo Bills encounter the mountainous flesh of the Washington Redskins.

Chances are, they will also see a Bill or a Redskin carried supine hors de combat. American football, a sport that rewards brute force and high pain tolerance with victory, exacts an appalling physical toll. Every one of the NFL's 1,200-odd players is likely to be injured during a four-month season; many are hurt more than once. In the 1989 Super Bowl between teams from San Francisco and Cincinnati, viewers watched, in slow-motion, the tibia of Cincinnati's "nose-tackle", Tim Krumrie, snap in two. Mr Krumrie, at least, was able to play again. Last month, Mike Utley, a member of the Detroit Lions,

THE ECONOMIST

fell on his head. The impact crushed several vertebrae and paralysed him from the neck down.

Such severe injuries are the exception, and football is not alone in occasionally crippling its participants. But no sport matches it for the frequency of shredded ligaments, broken fingers, popped shoulders and the like. Injuries are so common that every professional football stadium, and many university-level ones, have an x-ray room for the examination of shattered limbs.

Nor do most players last much longer than gladiators. Players survive in the NFL, on average, less than four years before injuries or younger usurpers see them off. Steve Courson, a mammoth 295lb "tackle" for the Pittsburgh Steelers grimly recounted this life in his new book "False Glory", which describes players compelled to hide serious injuries and load themselves with steroids and other drugs to sustain their careers. Don Strock, a former quarterback recounts in his own recent memoirs how players would gather around an injured team-mate during a game to screen from spectators the use of pain-killing injections, then hide the needles under the carpet-like synthetic "turf".

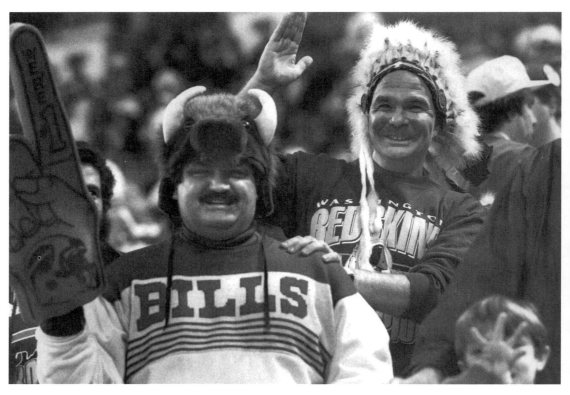

Costumed and ready to appear on camera, fans enact the prescribed stereotypical behaviors triggered by cutaways on network sports broadcasts.

I looked like all of the other photographers in the northeast quadrant, almost. I wore my
color-coded vest, and my body was draped with three cameras, although I didn't use the
"big, fast glass," the 400 mm lenses, that rooted my counterparts to their sideline positions.
 I felt self-conscious, though, because I wasn't photographing the game like everyone else. The
interactions in the stands interested me more, but I could feel the eyes of security guards on me as I
moved along the sidelines and out of my assigned quadrant. I hesitated to stand, back to the field,
and shoot the game my way. I didn't know whether my field credentials permitted me to engage in
aberrant behavior. After a while I noticed other photographers making an occasional about-face,
and I grew more comfortable with the idea. As I aimed my lens at the crowd I found two men in
my viewfinder, each garbed in distinctive team regalia. They shifted their attention from the game
to me and performed what they must have considered camera-appropriate actions. In character
with the headdress he proudly wore, the Redskins fan did a "tomahawk chop" on the shoulder of
the man seated below him, who responded by waving his foam-enhanced index finger in the air,
chanting the words written on it: "We're number one!" Far from opponents, these two men acted
the part of fellows, unruffled by the hard-hitting competition on the field. After all, they were
members of the same team.

Marilyn Carlson Nelson entertains her guests in the Carlson Companies' suite on the 50-yard line. Nelson introduces latecomers, envelope magnate Harvey Mackay and Minnesota Senator David Durenberger.

**Fans at homeless shelters
talk strategy, politics, money**

Two men, residents of the Twin Cities' largest homeless shelter, compared notes on the Bills and the Washington Redskins before the Super Bowl game began yesterday.

Buffalo, they agreed.

"Only because they lost last year," one said. "Very few teams lose twice."

More than 400 men stayed at the Drake in downtown Minneapolis yesterday. Some were new to the place. Others have been there a while. They sleep five, six, eight to a room, usually on vouchers from the county.

A few went outside during the game or at halftime and glanced down the street to where searchlights painted the sky above the Metrodome and where scores of buses and limousines idled, waiting for people lucky enough or wealthy enough to be at the game.

Marion (Pop) Johnson watched in the Drake's no-smoking lounge, which was as usual thick with cigarette smoke. No alcohol is allowed inside the shelter, but it still was something of a party.

About 40 men, most of them young, watched the game from the battered chairs or bedrolls propped against walls or from folded metal bedsprings, pried apart just enough to form a sort of loveseat. About 50 more watched in the smoking lounge, no smokier but better furnished.

Most of the men at the Drake cheered for Washington, but "da Bills" had followers, too. A couple of people slept through most of the first half.

Like fans all over the city and the nation, they talked strategy—"They gotta stop Washington's receivers"—and they talked politics—"That name 'Redskins' is racist, isn't it?"

And they talked money. "Even the losers get a million dollars tacked onto their paycheck," one man said to nobody in particular.

Fans *continued on page 131*

Faces adrift in a sea of Coca-Cola logos, spectators rehearse their role in the halftime production, "Winter Magic."

Spectators were enlisted to play a role in the halftime show, and each received a brightly colored card emblazoned with the Coca-Cola logo to use in the three "card stunts." The show was an extravaganza in four acts, called "Winter Magic," a "salute to the fun and fantasy of the winter season," complete with an orchestra, a drill team, a "snowflake drill team," dancers, snowmen, dancing snowmen, ice skaters, famous ice skaters, and the feature attraction, Gloria Estefan, all punctuated by deafening pyrotechnics. I had never really thought of Minnesota winters in terms of their fun and fantasy, but the halftime show seemed to present one more opportunity to sell the crowd on this "winter travel destination." There was more soft-selling going on in the stands. GTE provided seat cushions to enhance spectators' comfort. Banners draped the stadium, representing corporate giants like Dairy Queen, Coca-Cola, and Budweiser, and the Sony Jumbotron provided another vehicle for commercial speech. At the pinnacle another banner, star-spangled, consecrated the all-American assembly.

Donald Trump and Marla Maples cheerfully accommodate the steady stream of autograph seekers during halftime.

It wouldn't be a major social event without a couple of sightings of The Donald and Marla Maples.

As they wriggled through the crowded concourse to their seats on the 50-yard-line, Trump and Maples stopped to chat with fans and sign autographs. Those who got near them described them as obliging and friendly, saving the harshest criticism for the couple's pushy manager. The star couple also caused a major traffic jam behind them in the concourse.

At halftime, rather than cause more concourse gridlock, Trump and Maples asked an usher to bring them four ice cream sundaes at $1.75 a piece. They gave the usher $30 and told her to keep the change. But the usher declined.

MINNEAPOLIS
STAR TRIBUNE

Other celebrity sightings include Joe Montana, Dan Rather, Leslie Stahl, Eddie Albert, Eleanor Mondale, Muhammad Ali, who signed autographs for about two dozen onlookers, and boxing champ Evander Holyfield. At one point during the game, two young women followed Holyfield to a restroom and waited outside for several minutes. When he came out, they snapped his picture and scurried off.

Seated in the stadium's last rows, the least privileged of all ticket holders remained until the final seconds ticked off the clock.

Another lopsided Super Bowl drew to a close. I worked at a frenetic pace, trying to shoot as much as possible before the stadium emptied. I hadn't eaten since early morning; this, at least, distinguished me from the well-fed press corps. All day I had made on-the-spot decisions about where to be, at what point in time, in order to photograph what seemed significant. I found many sites and activities pregnant with stories-for-the-telling, but I always heard the minutes ticking away and, opting for the big picture, I kept moving. I knew that, despite my serendipitous encounters with the Jills and the FBI, others had been spared my inquisitive gaze. Except for the brief time in a luxury box with Marilyn Carlson Nelson, I knew that I would never photograph the captains of industry ensconced in the other boxes. While I might gain access to the winning team's locker room at the end of the game, I would never gain access to the secluded environs of the Fortune 500, the real champions of the contest. Acknowledging these limitations, I decided to scale the heights of the Metrodome and seek out the stadium's worst seats. There, dwarfed by the Sony Jumbotron, sat glassy-eyed people with too little fame or fortune for the 50-yard line. With reckless disregard for my fear of heights, I turned to see what the field looked like from the last row of the end zone. The vast expanse of the stadium greeted my wobbly gaze. The players below looked like the blister-packed toy figures I had been given at one of the parties for the press. I could see spectators leaving to beat the crowds sure to fill local bars and restaurants. Midway through the fourth quarter the game held little interest for even the die-hard fans who had journeyed to frigid Minnesota to witness the match. Up near the rafters, a group of bored-looking Super Bowl fans hung on to the bitter end, savoring their NFL experience.

At the two-minute warning a triumphant Redskins fan demonstrates his jubilation for photographers seeking closing shots.

Fans *continued from page 127*

Johnson, 55, said he played high school football in Missouri. He thought he was good enough for college ball, but he was passed over at scholarship time and didn't go to college. He played quarterback in high school.

"Most of the guys here would like to be over there at the game, but they're here watching because they don't have the currency," he said. "Some of them went over to where they have those big screens to watch."

"If it wasn't on TV, I'd be listening on radio. But even if I had the currency, I wouldn't go because I have sensitive hearing. I don't think I could take the noise inside the Dome."

"A friend of mine, a blues singer, is over there. He asked me if I was going to the game. I told him no and he asked me why. I said I don't have a ticket."

MINNEAPOLIS
STAR TRIBUNE

He's looking for work, he said, but because of a back injury can't do heavy lifting. He'd like to find a job managing an apartment building—he did that some years ago— "but they usually hire retired people for that."

The friend offered to get him a ticket, Johnson said, even if he had to pay a scalper several hundred dollars. "But that's illegal," he said.

"And even if I could buy a ticket, I can't dress well enough to go. You've got people over there, they're wearing a good dress shirt and a nice pair of pants and maybe a tie."

He ran a hand over his clothes, clean but worn, a worker's clothes—or in this case a working man out of work. Johnson said police or security officers would stop him and ask to see his identification if he went near the Dome. They would see his address and send him on his way.

"They see that we're homeless and they assume we're over there to steal," he said. You need an address."

An address other than the Drake, he meant.

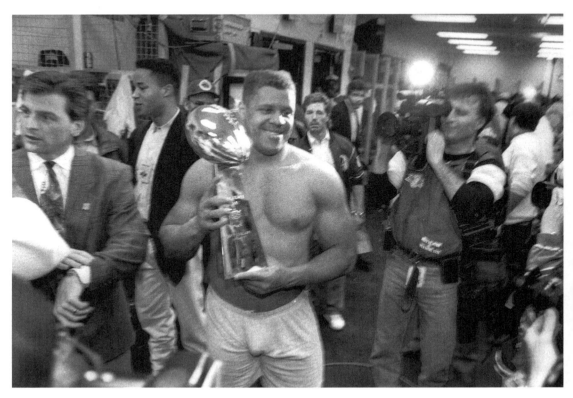

After their victory the Redskins joined together in the locker room and knelt in prayer. After intoning their solemn "amens" several players burst out, "Let's party!" and the locker room frenzy erupted.

At the end of the game I found myself swept up in the tide of photographers moving toward the locker room to make their closing shots representing the thrill of victory. I had no particular reason to place this event on my visual agenda, but the momentum of the crowd made my decision for me. The object of this game, as I'd discovered on Media Day, was to get as close as possible to the most notable people and events, as if a close up, unobscured by other photographers or reporters, was like scoring a touchdown. Since I had joined the fray I resolved to contend for a prize image. As I swept through the locker room door I confronted chaos. Heat and humidity enveloped me along with the sweet scent of too much aftershave. Photographers bumped and jostled each other as they established advantageous positions in anticipation of whatever might occur. Suddenly a player appeared in his underwear, carrying the trophy. The sea of photographers parted, allowing Raleigh McKenzie to strike a pose for them. He stood off to my left and I quickly pivoted and rattled off several frames before he was swallowed up by reporters and vanished from view. I had my locker room trophy. Representatives of the press continued squeezing in, and with characteristic contrariness, I squeezed out, hoping that the cold fresh air outside the dome would work its winter magic on me.

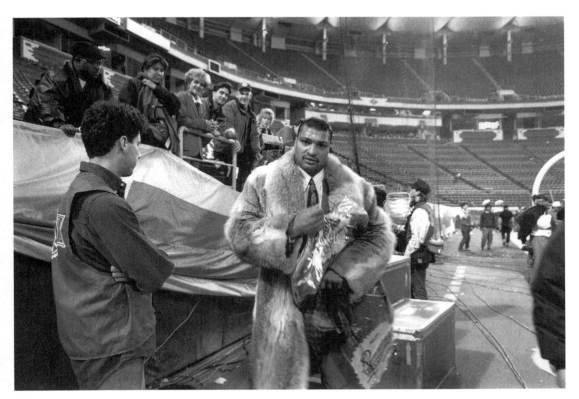

Buffalo linebacker Darryl Talley emerges from the locker room chastened after suffering a lopsided defeat by the Redskins. "It's painful any time you lose a football game. But you are a professional and you have to start to look around and say, 'What's going on? What am I not doing right?' You have to go back and do a little soul-searching on your own."

School is out for the day in Atherton, Calif., and 9-year-old Jim Plunkett Jr. rushes home to ask his father to join him for a game of one-on-one basketball.

Jim Plunkett Sr., the former NFL quarterback and Super Bowl MVP, smiles as his son walks through the door and agrees to play, even though the pain in his left knee screams in protest. The game proceeds, and the pain begs him to stop. But Plunkett continues until the game is complete, much like he did throughout his injury plagued career with the New England Patriots and Los Angeles Raiders. Then it's time for Plunkett to take his anti-inflammatory medicine.

Publicly, coaches deny that they force players to play hurt and say that they leave that decision—with no spoken or unspoken directive—up to the players themselves.

"As a coach, I've always had the

MINNEAPOLIS
STAR TRIBUNE

philosophy that nobody knows your body like you do. The players' feeling is the No. 1 criterion that we use in making any judgement," said Marty Schoppenheimer, the Kansas City Chiefs' head coach. "It's always difficult, but at the same time you recognize that it's the nature of our business."

But privately, some admit that players who do not like to play with pain often end up not playing at all. "Sometimes you look at these guys and you get sick of looking at them," said one former Super Bowl coach.

Despite all the injury risks—both physical and financial—the NFL's 28 teams need not worry about finding willing participants . . .

"Somehow it's worth it," Plunkett said. "In this business, you can't get around injuries. It's a violent, collision-type sport. But would I do it again? Yes I would. It beats working in a coal mine or an atomic plant."

ESPN's postgame show, staged on the Metrodome's deserted turf, hosts Redskins coach Joe Gibbs fresh from the victory celebration in the team's locker room.

At last the game was over. The clamor in the stadium diminished and all but the most devoted fans had moved on to the next event—postgame in the bars and restaurants of Minneapolis. A hive of reporters still occupied the press box, busily dispatching their stories so they could join their colleagues at the press reception at the hotel. Eyes on the floor, silent stadium workers made their way through the vacant stands picking up trash left in the wake of exuberant fans. On the field below, broadcasters claimed the turf for their postgame stand-ups and interviews. Victorious Redskins coach Joe Gibbs proclaimed his continuing commitment to football: "If I was smart I might step aside, but I'm not very smart. [My wife] Pat and I are excited. I know the odds are not good that we'll be here again. But we love what I do. There are negatives, but games like today make it worthwhile. I have no thoughts of stepping away. We'll be teeing it up again next year." Like Gibbs I couldn't stop. A few other photographers remained on the field, collecting the shots that would end their stories. One by one they headed for the hotel. But I hadn't yet found the closure I sought. Despite fatigue and hunger, my commitment to telling a different story drove me to keep shooting while the Dome shut down around me. Police began to shoo away the clutch of fans still waiting for a final glimpse of their departing heroes. Security guards watched me and smiled. I realized I might be ushered out next, despite the privilege bestowed by my press tag. I shot frame after frame, waiting for the moment when I would know that my story had ended. I glanced at my watch: more than an hour past the time I had promised to meet my ride home. That was the only closure I would find. Exhausted and exhilarated by the day's work, I tore myself from the Metrodome. Outside, the cold air arrested my thoughts. I crossed the empty streets and headed toward the car, hoping to find sympathetic friends awaiting my delayed return.

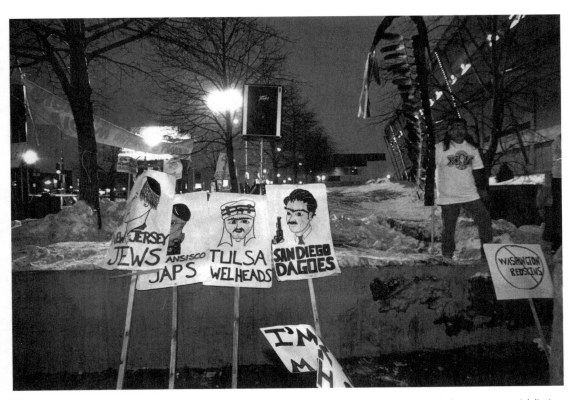

Members of the American Indian Movement remove the remnants of the day's demonstrations as visitors invade the city's commercial district.

3,000 Indians, supporters denounce mascot names

About 3,000 Indians and their supporters rallied outside the Metrodome Sunday to protest the use of Indian mascot names by sports teams.

They were protesting the use of the term "Redskins" and other Indian names by sports teams, which they said is racist and degrading.

Minneapolis police reported no serious incidents and no arrests during the protest, which occurred as fans entered the stadium.

"Why don't you go back to the reservation," shouted a 24-year-old St. Louis woman who did not give her name. But Dean Grayson, 27, an attorney from Chevy Chase, Md., and a Washington fan, said, "They need to change the name. I can see how it's racist."

MINNEAPOLIS
STAR TRIBUNE

Amy Ollendorf, 30, of Minneapolis, attended the game with her family from Washington, D.C. As the demonstrators marched by, she applauded. "I support their cause and I'm a Washington fan," she said.

But another fan, Tim Miller, 37, of Albany, N.Y., shouted at demonstrators, "Go home!" He said, "This is baloney. It's totally out of hand."

The protesters marched from the Peacemakers Center to the Dome. By the time they had reached the stadium, their numbers had swelled to 3,000, according to an estimate by Deputy Police Chief David Dobrotka. Demonstrators marched around the Dome twice. "We're circling the covered wagon," Clyde Bellecourt, American Indian Movement national director, said with a grin.

Bellecourt told protestors that the use of headdresses and war paint meant racist caricatures of Indians. "They call us radicals and militants," he said, his voice hoarse from speaking. "Only a few years ago they were calling us savages and heathens."

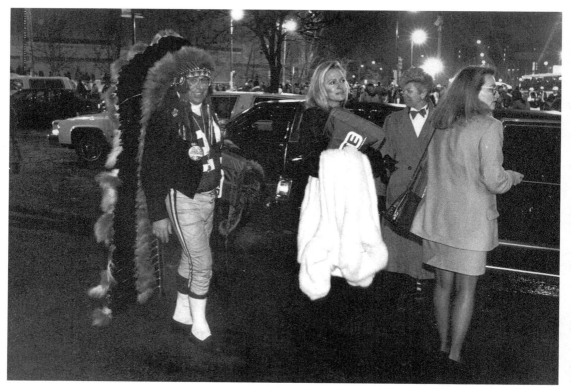

At the conclusion of the game, visitors board waiting limousines for the return trip downtown. Fireworks exploding above encourage continued festivity and additional spending.

Where was my final shot? This dilemma continued to plague me. Even though I had lingered at the Metrodome searching for a definitive image, a photograph that would make my meaning precise and unambiguous, I left hoping that someone else had more success than I. While editing unwieldy stacks of workprints I scrutinized each of the images we had produced, assessing its potential as a "closer." What photograph could appropriately end this story? While narratives routinely impose a sense of closure, this one seemed to resist resolution. The multiple threads running through our Super Bowl story relentlessly weave a gaudy, deformed tapestry of extravagance and want, hegemony and resistance that expands while threatening to unravel. The Super Bowl plays in cities across the country, year after year, and draws a burgeoning audience willing and wanting to believe, if only briefly, that the spectacle taking place is a game. Super Sunday has become a profitably commercialized holiday, fashioned to perpetuate the social and economic regime of corporate capitalism. Unsated by the profits drawn from its vast domestic market, like other multinationals, the NFL has launched a "globalization" campaign to sell American football abroad, along with its licensed products, and its ideology. No single photograph in my collection conveyed this unresolved conclusion. What does continuing contestation look like?

PITTSBURGH STEELERS
300 STADIUM CIRCLE
PITTSBURGH, PA 15212
412/323-1200

EXECUTIVE OFFICE

28 January 1992

Dear Wheelock:

The Super Bowl Festivities in Minnesota and St. Paul were great. We all had a wonderful time, and were met by friendly and helpful folks everywhere. The Super Bowl Task Force did a great job.

The traffic went beautifully. The snow on Friday night was just the perfect touch. The parties, the facilities and the locals were just great for the fans. Both the Redskins and the Bills had a good time even though it was a tough game for Buffalo.

Please accept our most sincere appreciation for a job well done.

Thank you and all the best.

Sincerely,
Daniel M Rooney
Daniel M. Rooney
President

DMR/me

SHANOR ELECTRIC SUPPLY, INC.
285 HINMAN AVENUE BUFFALO, NEW YORK 14216

January 28, 1992

Dear Committee:

I would like to say to everyone involved in organizing Super Bowl Ambassadors Host's a "Tremendous Thank You".

In over thirty years of traveling, my wife and I have <u>never</u> been greeted and helped with more courtesy. Your ambassadors all acted as they were paid professionals and I know that they are all volunteers. I also know how much work that can be, as I have done my share, and we all know how rewarding it can be.

From the time we arrived at the airport until the time we left, we felt like we had our own personal tour director with us at all times. The Minneapolis/St. Paul area can be proud of the job they all did.

I wish we could personally thank each and every person for a job well done. Hopefully, someday Buffalo will be the host and do as well. It certainly will be a tough act to follow, (if not impossible).

Again, thank you. Everyone I've talked to from The Buffalo Area all have the same feelings and all look forward to returning to your cities.

Sincerely,

JOHN AND SUE SHANOR

Jack and Sue Shanor

Sheraton Park Place Hotel
The hospitality people of ITT

5555 MAYZATA
BOULEVARD
MINNEAPOLIS, MINNESOTA **55416**

To all of the wonderful people in Minneapolis:

We had the pleasure of being in Minneapolis to attend the Super Bowl. We want to congratulate and thank all of you who worked so hard to make us feel welcome!

We felt good as soon as we arrived at the airport and saw the colorful balloons. It was the perfect festive touch!

All of the "Hot Hosts" were friendly and helpful. They really seemed to enjoy what they were doing. A "special thanks" to the hosts who stood out in the cold, giving directions and shuttle information.

The shuttle service was a great convenience and we used it to see as many sites and events that time would allow.

We appreciate all of the extra efforts that you put forth. It must have taken an enormous amount of planning, co-ordination, co-operation...(and prayer!), to make it all work so well. You did a wonderful job! You should feel very proud!

Sincerely,
Mr. and Mrs. Low
7610 Vicky Ave.
West Hills, CA 91304

GIANTS
DIGEST THE GIANTS FANS PAPER
179 NOTTOWAY LANE, TOMS RIVER, N.J. 08755

February 14, 1992

Minnesota Super Bowl XXVI, Inc.
2126 Plaza VII
45 South 7th Street
Minneapolis, MN 55402

Gentlemen:

Just a short note, somewhat overdue, to extend our gratefulness to you and your volunteers for a most splendid Super Bowl!

From the moment our plane landed, and our ambassador greeted us, everything went Super during our stay in your fine city! You are to be congratulated and commended for your warm and steadfast efforts in providing the many amenities to make this a most memorable Super Bowl.

Super Bowl XXVI was our publication's 13th in covering a Super Bowl and, it was by far, our best thanks to your efforts. We will lobby editorially in hoping the league will return to your fine city in the future!

Thanks once again for your warm hospitality and perfect planning!

Sincerely,
Henry DeBianchi
Henry DeBianchi
Publisher

HD/jl
Member: Pro Football Writers of America

On Monday morning the corporations folded their hospitality tents and left town. All the giant inflatables, the rival Coke and Pepsi cans, Budweiser cans, and footballs retreated from their posts on rooftops and on the streets near the Metrodome. The strolling Pillsbury Doughboy and Little Green Sprout were shelved until the next corporate holiday. Local businesses dispatched employees to scrub off the Super Bowl logos adorning their storefronts, and the Basilica took down its welcome banners. Outside the stadium, crews loaded semitrailers with miles of cable and the truckloads of equipment used to broadcast the Super Bowl to the world. Inside, janitorial workers picked through the stands, clearing away the debris. Musicians briefly resumed their posts at the grand pianos in the airport, and Super Bowl XXVI Task Force ambassadors bid the journalists and visitors jamming the terminal a warm Minnesota farewell. Slowly, Minneapolis and St. Paul resumed their former appearance, and before long local newspapers stopped running stories about the Super Bowl and turned their attention to other matters. Wrung out by ten days of nonstop photography, we retreated to our darkrooms with great expectations, and prepared for the long and arduous task of making sense of our experiences, and fashioning a statement to penetrate the glossy surface of corporate-sanctioned representations.

Members of the Super Bowl XXVI Task Force returned to their corporate offices scattered across the metro area, reuniting in late January to celebrate their success at a gala party for all the volunteers. The task force never bothered to commission a follow-up study assessing the economic impact of the Super Bowl. Tracing the dollars actually generated by a single event is an extremely difficult task. Prediction is easier—it requires plugging hypothetical figures into a theoretical model. Undaunted, in *The NFL and You, 1992-1993* the league boasts the positive impact of Super Bowl XXVI: "The Super Bowl provides tremendous economic impact for the host city. An estimated $50 million was generated in the Minneapolis-St. Paul-Bloomington area, host of Super Bowl XXVI, according to a study conducted after the game." I called the NFL asking about the study, but the league couldn't give me a citation. No one seemed to know where the figures came from, not the NFL, not the Chamber of Commerce, not Wilbur Maki, the University of Minnesota professor commissioned to provide the initial economic forecast.

I did manage to find one indicator of the Super Bowl's economic impact. Estimated sales reported by Carlson Companies, Inc., task force chair Marilyn Carlson Nelson's travel and hospitality giant, spiked to $2.9 billion in 1992, up from $2.4 billion the year before. In 1993, with no Super Bowl to occupy Carlson travel agents or fill Radisson hotels, company sales returned to their previous mark. No one really knows whether or not dollars trickled down into the pockets of Minnesotans, but faculty and staff at the University of Minnesota endured another round of salary freezes, exacerbated by university-wide budget cuts inflicted by the state legislature. And I can report that my property taxes increased significantly during subsequent years.

Like the Super Bowl XXVI Task Force, the American Indian Movement worked hard to exploit the media attention focused on the community, but the well-organized, peaceful protests failed to convince professional team owners that names like "Redskins," "Chiefs," "Braves," and "Indians" perpetuate racism. Fans still dress in chicken-feather headdresses and do the "tomahawk chop," despite AIM's persistent efforts to educate the public about the offenses their actions perpetrate. Professional football continues to provide a vehicle for expressions of racism. Now and then broadcasters let slip the

carefully suppressed attitudes that some hold regarding the racial characteristics of the athletes they cover, the men upon whose labors sports broadcasters' own jobs depend. Minority athletes still find themselves stereotyped on the field and crowded out of the front office.

Native and African Americans don't suffer their exploitation alone. All NFL players lead a dual existence, idolized for their achievements on the field and commodified by the front office, flip sides of the same coin. The pages of NFL promotional literature relentlessly trumpet players' heroic feats and the league's spectacular legacy, while team accountants figure the depreciation on the value of these heroes, like so many aging company cars. When the league exhausts their vitality, players must mobilize whatever resources they placed in escrow before turning professional while under the yoke of their high school and college coaches. But statistics demonstrate that attractive career opportunities evade most retired players, especially those who continue to struggle with injuries inflicted on the turf.

Despite the many risks associated with football, the NFL can tap a plentiful supply of new recruits ready to claim their brief moments of gridiron glory, moments that provide a lifetime of "war stories" to go along with the injuries sustained in combat. War analogies, gladiatorial metaphors, references to circuses, and more recently, invocations of corporate America—all these figures of speech attempt to capture the essence of professional football but fall short of portraying the complexity of the spectacle we have learned to consume.

From my appointed place on the sidelines I can still see the glass wall that partitions this patriarchal arena from my corrupting feminine embrace. But little of what I see on the field attracts me; I have no particular desire to penetrate the barrier. The snap, crackle, and pop of colliding armor-clad bodies makes me cringe. So do the dance routines cheerleaders perform on the sidelines, and the roles played by women in the beer, razor, and car ads I see when I watch the game on television. The intensity of NFL coaches dumbfounds me. It's just a game, right? (Wrong.) Maybe I just don't get it. After all, football was not invented for the amusement of women. It's a forum for stereotypic masculinity, defined in opposition to stereotypic femininity, and designed to inculcate competitiveness, aggression, and heroic self-sacrifice.

Football was supposed to counteract the emasculation resulting from industrialization. But arguments against the social consequences of industrialization have quieted over the last century, as industrialization became the machine transforming the game into a lucrative commodity, an entertainment spectacle. The social consequences of playing football have changed too; in 1992 no one argued that the attributes nurtured on the gridiron transform players into CEOs or statesmen. Players perform the labors—and they are wellpaid, if only briefly—but NFL team owners reap the long-lasting rewards: wealth, power, and political influence. Just as the State has sustained this equation in the past, there is no reason to anticipate change. Attacks on football are as un-American as assaults on Mom, apple pie, and the flag—quintessential cultural icons.

Is contesting the Super Bowl an affront? I am nagged by the notion that I must end by outlining the positive attributes that salvage football in some way, thus rescuing our statement from potential accusations that we looked at the Super Bowl through a

distorted lens. I could argue that the Super Bowl performs an integrative function, bringing together diverse audiences into momentary communion, cementing ties among Americans of all colors and classes. That argument rings hollow for me, especially since so many women have a hard time communing with men who are busy asserting their difference. And I can't rescue our critique as did Michael Real, with an admission of the pleasure I draw from football, despite the social ills it represents and perpetuates. An aesthetic argument might provide the vehicle for a graceful exit, but the dominant messages encoded on the field, and the intentions of the choreographers guiding the production, make it too implausible for me to forward such a view. The only salvation our investigation can offer is the potential for liberation that self-scrutiny and reflection can yield.

Acknowledgments

Many friends and colleagues generously offered assistance that facilitated the production of this book. I am indebted to the photographers who enthusiastically worked with me on the "Super Bowl project" and contributed their energy, talent, and hard work, all at a moment's notice. I am especially grateful to David Rae Morris and Randy Johnson for their extraordinary effort and unwavering support. Once the shooting and editing were completed, Gina Dabrowski entered the darkroom and, with her usual consummate skill, produced the prints for the book. Joan Schwartz provided crucial assistance: she scanned all of the photographs and helped me learn desktop publishing. Pat Thompson consulted with me on the layout and design of the manuscript. David Perlmutter provided invaluable research assistance, accompanied by useful feedback and a healthy dose of humor.

In addition to the individuals who facilitated my work, the Minnesota Historical Society gave me permission to use the Super Bowl XXVI Task Force records housed among its collections, and the NFL provided press credentials for several of the photographers on our team, along with two passes to the Super Bowl.

A most elusive commodity—time—became available to me through a postdoctoral fellowship at the Annenberg School for Communications at the University of Pennsylvania. As a participant in the Annenberg Scholars Program during 1995-96, I benefited from my fellow scholars' successive responses to various parts of this manuscript, and their sagacious comments sharpened my writing. David Buckingham, Crispin Sartwell, Gene Burns, and Michael Griffin all provided valuable feedback. I am especially grateful to Elihu Katz, who, in his role as director of the scholars program and intellectual ringleader, sparked many ideas that made their way into print.

Several friends and colleagues took time away from pressing tasks and read the completed manuscript. They offered useful comments along with much appreciated encouragement. Thanks to Larry Gross, Jay Ruby, Howard Becker, Doug Harper, Elizabeth Chaplin, Jon Prosser, and Leola Johnson for their valuable insights, support, and good counsel.

For several years my family endured the ups and downs of the "Super Bowl project." My mother, Joan Schwartz, assisted me with the production of the book, read and commented on parts of the manuscript, and encouraged my efforts. My task would have been much more difficult without the help she so generously offered

On many occasions my Super Bowl-weary children took care to step gingerly around the work prints scattered across the floor of their play space, and they remembered not to venture into the darkroom unanticipated. The regular reality checks they prompted injected the sometimes ponderous business of making a book with much-needed levity. Most important, they helped focus my crusading spirit. This book is dedicated to Daniel, Eric, and Lara, my most profound sources of inspiration.

—DONA SCHWARTZ

Photo Credits

Michael Branscom 60

Diane Bush 25, 71, 79, 101, 102, 110

John Haselmann 67, 131, 132

Randall Johnson 33, 64, 65, 68

Donna Kelly 61, 63

Amitava Kumar 104

David Rae Morris 4, 24, 27, 30, 37, 38, 40, 41, 51, 52, 54, 56, 58, 59, 69, 70, 105, 106, 107, 108, 109, 113

Steve Schneider 28, 29, 34, 53, 55, 62, 74, 80, 115, 120, 121, 122, 124, 127, 128

Dona Schwartz 22, 32, 35, 36, 39, 66, 72, 75, 76, 77, 78, 82, 83, 103, 111, 114, 116, 117, 118, 119, 123, 125, 126, 129, 130

The Photographers

Michael Branscom was born in suburban Philadelphia in 1970. He tried playing football in 8th grade, but quit after the first game. Branscom returned to the football field when he joined the Super Bowl project in 1992. He worked as a staff photographer for the *Minnesota Daily* from 1992-1993 and earned his BA in Journalism at the University of Minnesota in 1993. After working as a freelance photographer in Minneapolis and a four month stay in India he returned to Philadelphia. He is currently the staff photographer for *Philadelphia Weekly*.

Diane Bush received her MA in Journalism and Mass Communication from the University of Minnesota. She works as a newspaper photographer in Utah, and prefers hikes in the mountains to big-city spectacles. Her personal work explores the relationship between cultural events and daily life.

John Haselmann is a 1993 graduate of the University of Minnesota School of Journalism and Mass Communication. He had completely ignored the NFL until it lumbered into town in January 1992. He works as a digital darkroom technician for the *Minneapolis Star Tribune* and lives in St. Paul. He could not name a single member of the Minnesota Vikings to save his life.

Randall Johnson received his MA in Journalism and Mass Communication from the University of Minnesota, where he taught photojournalism for five years. He has photographed for Agence-France Presse, Reuters, and the St. Paul *Pioneer Press* among others. He recently completed a year-long documentary project about a group of hard-drinking drag racers.

Donna Kelly is a freelance photographer specializing in dance and performing arts photography, and she runs Donna Kelly Photography in Minneapolis. Kelly has lived and worked in China, India, Ireland and Italy, and she covered the Womens Peace Conference in Beijing for the St. Paul *Pioneer Press*. She earned a BA in Chinese Language and Literature from the University of Minnesota.

Amitava Kumar teaches in the English department at the University of Florida, and he is a contributor-member of Impact Visuals, a New York-based photographic cooperative. His photography and writing have been published most recently in *Critical Inquiry*, *Cultural Studies, American Quarterly*, and *Rethinking Marxism*. He is completing a book-length project, *Passport Photos*.

David Rae Morris grew up in New York City. He holds a BA in photography and theatre design from Hampshire College and an MA in Journalism and Mass Communication from the University of Minnesota. He is a member of Impact Visuals. He currently lives in New Orleans, where he is finishing a book on Deadheads. In stark contrast to his work on Super Bowl XXVI, Morris photographed the events leading up to Super Bowl XXXI for money, and thereby became a part of the spectacle critiqued in *Contesting the Super Bowl*.

Steve Schneider received an MA in Journalism and Mass Communication from the University of Minnesota. He runs Steve Schneider Photography in St. Paul, Minnesota.